IMAGES
of America

DENVER'S CAPITOL
HILL NEIGHBORHOOD

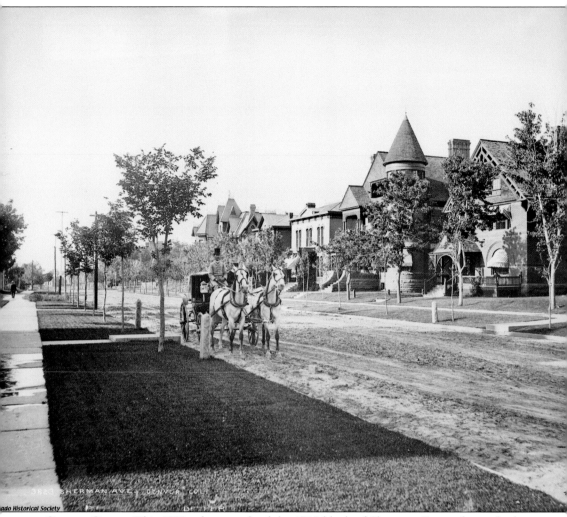

ON THE COVER: This 1890s photograph of the 1700 block of Sherman Street shows the large houses that once stood there. Though no evidence remains today, Sherman Street was once filled with mansions. (Photograph by William Henry Jackson; Colorado Historical Society.)

IMAGES
of America
DENVER'S CAPITOL
HILL NEIGHBORHOOD

Amy B. Zimmer

ARCADIA
PUBLISHING

Published by Arcadia Publishing
Charleston, South Carolina

Printed in the United States of America

Library of Congress Control Number: 2009928333

For all general information contact Arcadia Publishing at:
Telephone 843-853-2070
Fax 843-853-0044
E-mail sales@arcadiapublishing.com
For customer service and orders:
Toll-Free 1-888-313-2665

Visit us on the Internet at www.arcadiapublishing.com

To Mom, with lots of love.
Your help and encouragement mean so much to me.

CONTENTS

ACKNOWLEDGMENTS

I couldn't have done this book without the valuable help of a number of individuals. First of all, I would like to thank fellow author-historian Shawn Snow, whose book, *Denver's City Park and Whittier Neighborhoods*, is being simultaneously published by Arcadia. Shawn suggested the idea for this book and helped keep on the lookout for photographs for me. Thanks also to my editor, Jerry Roberts.

Dr. Tom Noel, mentor and friend, was extremely generous in opening up his vast photograph collection. My gratitude also goes to the many individuals who shared their photographs and family stories, especially Alan Golin Gass, Janet Greiner, Rod Greiner, Roy Klein, Gary Kleiner, Fred Zint, and others whose names I'll never know but whose great stories contributed to this work just the same. Thanks also to Andrea Furness at Capitol Hill United Neighborhoods (CHUN) and the staff at *Life on Capitol Hill*, the neighborhood's monthly newspaper, for helping spread the word about my search for photographs.

Librarians and archivists are very special people. My sincerest thanks go out to those who patiently helped me sort through innumerable wonderful photographs: the always-knowledgeable Bruce Hansen and Coi Drummond-Gehrig of the Denver Public Library; Lance Christiansen and Paul Levit of the Colorado State Archives; David Hays, Patrick Potyondy, and Brad Arnold at the University of Colorado–Boulder's archives; Rebecca Lintz, Jennifer Vega, and Caitlin Deane of the Colorado Historical Society; and Steve Fisher, fellow Arcadia author, of the University of Denver.

I've been lucky to serve on the board of CHUN with a number of great individuals who have all been very supportive, and I thank them, too, for all the good work they do in the neighborhood. I'm especially indebted to my fellow CHUN Historic Preservation Committee members, Jim Peiker, Brad Cameron, Michael Henry, and Randy Swan, for their helpfulness.

Last, but certainly not least, thanks to my family—my mom and dad, Pam and Neal, and my sister, Marcie—and to my sweetheart, Joel, for all their support. Somehow, I developed a love for old mansions when I was about eight years old and would often plead with my suburban mother to take me to Capitol Hill to look at houses. My deepest thanks go to Mom and Dad for encouraging that interest and for a lot of happy memories along the way.

INTRODUCTION

Since its founding, Capitol Hill has been a neighborhood of transition. Denver started at the banks of Cherry Creek in today's Auraria and LoDo neighborhoods, and throughout most of the 1860s and 1870s, the area that would become Capitol Hill seemed very distant from the city—so distant, in fact, that when Henry Brown, who owned a portion of the land in the area, donated a parcel of that land for a future state capitol, critics ridiculed the idea that the capitol would be so far out in the country. However, after the state accepted Brown's land and, in the 1880s, started building a capitol, the neighborhood kept growing. Wealthy businessmen who had made their homes on Fourteenth Street downtown saw Capitol Hill as an area far enough away from the central business district that they would be safe from the commercialization that encroached on their former homes. Capitol Hill became somewhat of a suburb, with large houses signifying the most prestigious addresses in town. John Wesley Smith, another early landowner, oversaw construction of a city ditch that would bring water to the neighborhood, leading to lush lawns, trees, and parks. In the 1880s and 1890s, anybody who was anybody sported an address on Lincoln, Grant, Sherman, Logan, or Pennsylvania Streets, or Colfax Avenue.

It would not be too long, however, until the neighborhood would again be transformed. This time, the evolution owed itself to transportation. As Denver and Capitol Hill gained more streetcar routes, traveling around the city grew easier. One no longer needed their home and place of business to be within walking distance. The popularization of the automobile continued this trend even further. Soon, like Fourteenth Street before it, the area around the Capitol would be abandoned as a wealthy residential enclave. A few of the original homeowners stuck it out, like Fannie Boettcher, who stayed in her Grant Street mansion until she died in 1952 at age 97. Most of her neighbors, however, had long since fled to areas like Cheesman Park, the Country Club, or south and east Denver. The area right around the Capitol, with its grand old mansions, became commercialized starting in the 1910s, as state buildings were constructed around the Capitol. By the 1920s, Colfax Avenue, once a grand residential boulevard, was zoned for commercial use. Now instead of ornate mansions, those living around Capitol Hill dwelt in the many apartments and guest houses being built in the area. Those mansions that escaped demolition were recycled as offices or apartments.

Farther east on Capitol Hill, however, areas like Cheesman Park continued to be bastions of the wealthy. Cheesman Park, located right in the center of Capitol Hill, had once been the site of the City Cemetery. When the bodies were removed in the early 20th century, a new building boom began in prestigious areas like Morgan's Addition near the park. Northeast and east of Cheesman Park, in the area of Capitol Hill often referred to as Capitol Heights, residents were more of a middle-class variety, and many of their cottages, bungalows, and four-squares have survived.

Along with the changes in the buildings, however, has been the change in the city's demographics. As a result, Capitol Hill, which today combines everything from fine mansions to halfway houses, is an incredibly diverse and thriving area with a unique character all its own. Further, it has started transitioning again. In the 1970s and 1980s, much of Capitol Hill could easily be described as "seedy." Hippies, drug dealers, and prostitutes mixed on the streets of the neighborhood. In recent years, however, changes in zoning, housing preferences, and the economy has led to Capitol Hill's emergence from its crime-riddled reputation. Capitol Hill's strong neighborhood association, Capitol Hill United Neighborhoods (CHUN), has contributed to the improvement of Capitol Hill through historic preservation efforts, zoning and liquor license issues, tree planting, and the annual Capitol Hill People's Fair.

Today luxury high-rises are being built, while many of the older homes are being restored. Yet with the wide variety of housing types, the neighborhood continues to attract people from absolutely all walks of life. This diversity of both residents and architecture is what makes Capitol Hill so exciting. In *Denver's Capitol Hill Neighborhood*, I have tried to capture the area's distinct character and to depict the full spectrum of people and places. Therefore, I have included both mansions and vernacular architecture, wealthy and middle-class, famous people and ordinary folks. To present as big a picture as possible, I selected my boundaries to be the area that most people think of as the larger Capitol Hill area. There is no real set definition of the boundaries of Capitol Hill; some place Downing Street as the eastern border; CHUN places First Avenue as the southern border. In this book, however, I have set the neighborhood as the area between Lincoln Street, Sixth Avenue, Colorado Boulevard, and Twentieth Avenue. I chose not to extend all the way south to First Avenue, as CHUN does, because places in this area, like Cherry Creek and the Country Club, have little in common with the rest of Capitol Hill, as well as being areas that could merit their own book.

In preparing this work, my hope has been that, by presenting the neighborhood's history through multiple facets, readers will be able to see how Capitol Hill's past made the area what it is today.

One

COLORADO'S CAPITOL

Gold seekers founded Denver City in November 1858, but it wouldn't be until 1867 that the Queen City of the Plains would beat out Golden and be officially designated the territorial capital. That fall, Gov. Alexander Hunt sent out a call for land for a capitol building site. Several people donated land, including former territorial governor John Evans, who donated a parcel of land in the Evans Addition (today known as the Golden Triangle) to try to bring higher property values to his development. It would be Henry Brown, though, whose land would finally be accepted by Hunt's Capitol Commission. Initially, many dismissed "Brown's Bluff," as the site came to be known, as too far from the center of town. But the site atop a hill overlooking the city sold many on the idea. By 1876, Colorado would gain statehood, but still nothing had been built on Brown's land. Disgusted, he tried unsuccessfully to get the land back three years later. Yet throughout the decade since Brown's donation, Denver had continued to expand eastward, as people started to move to the area around Brown's Bluff even before the state began construction of the Capitol in 1886.

Today the Capitol with its famous gold dome proudly stands high above downtown Denver and the thriving neighborhood that grew up around it, Capitol Hill. More than just the place where laws are made, Colorado's capitol building is a celebration of the state's history, with innumerable artworks and artifacts that tell the story of the Centennial State.

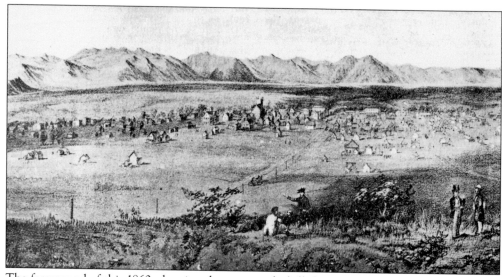

The foreground of this 1860s drawing shows part of a hill that is now approximately Sixteenth Avenue and Sherman Street, just north of the state capitol. Visible in the background is the tiny settlement of Denver, then concentrated around Cherry Creek and present-day lower downtown. The large building in the center of the drawing is the Lawrence Street Methodist Church, whose congregation would later move to Trinity Methodist at Eighteenth Avenue and Broadway. (*History of Denver*, Jerome Smiley, 1901.)

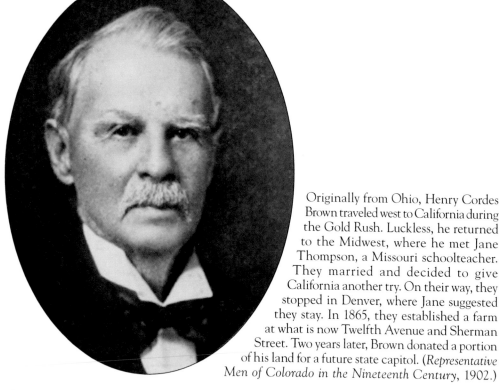

Originally from Ohio, Henry Cordes Brown traveled west to California during the Gold Rush. Luckless, he returned to the Midwest, where he met Jane Thompson, a Missouri schoolteacher. They married and decided to give California another try. On their way, they stopped in Denver, where Jane suggested they stay. In 1865, they established a farm at what is now Twelfth Avenue and Sherman Street. Two years later, Brown donated a portion of his land for a future state capitol. (*Representative Men of Colorado in the Nineteenth Century*, 1902.)

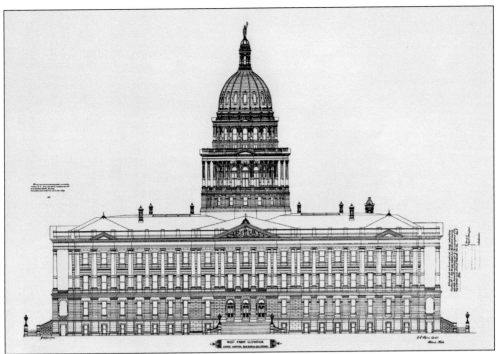

Architect Elijah Myers designed Colorado's statehouse. Myers had served as a structural engineer in the Civil War and built his career on designing courthouses, city halls, and state capitols, including the state capitols of Michigan, Texas, Idaho, and Utah. Shown here is an original drawing for Colorado's Capitol. Note the lady atop the dome, who did not make it into the final design, replaced instead with a lighted globe. (Colorado State Archives.)

Construction of the granite structure commenced on July 6, 1886. The Capitol would be dedicated four years later, on July 4, 1890. This photograph shows the building of the dome. (Photograph by C. E. Hightower; Tom Noel Collection.)

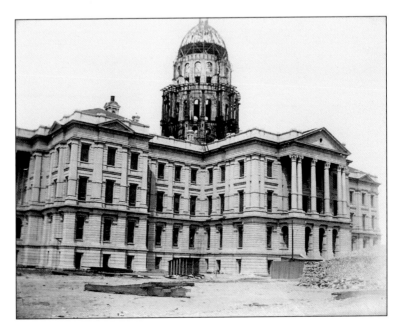

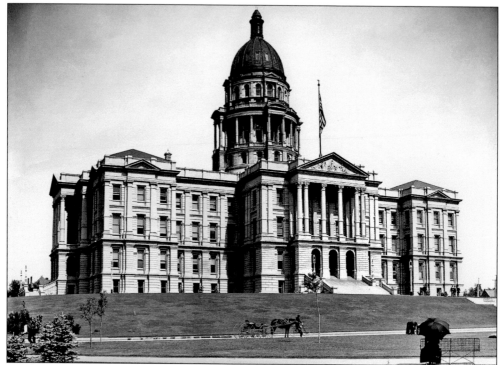

The famous gold dome did not appear until 1908. Originally, the dome had been copper. However, Frank Edbrooke, one of Denver's most important architects and a superintendent on the Capitol project, suggested a gold-leaf dome, which would both wear better than copper and reflect the state's mining heritage. This photograph shows the Capitol with its original copper dome. Gilding the dome cost $14,680 in 1908 and has required regilding several times since. (Photograph by Edmund B. Cooper; Jackson Thode Collection.)

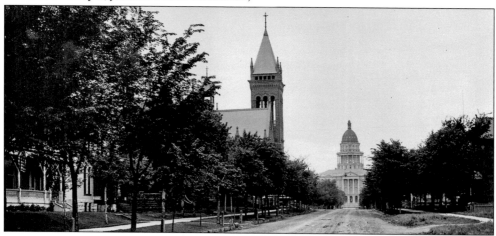

The Capitol site is bounded by Lincoln Street, Fourteenth Avenue, Grant Street, and Colfax Avenue. The building itself sits directly in the middle of Sherman Street, which does not go through from Fourteenth Avenue to Colfax. Here the Capitol is shown in a view looking south toward Colfax from Eighteenth Avenue. At the time of the Capitol's construction, Sherman Street was mainly residential. This photograph shows some of these houses, along with the Central Presbyterian Church on the left. (Tom Noel Collection.)

The Capitol consists of a basement, three main levels, and the dome. The building's design called for the offices of state officials, including the executive offices, to occupy the first floor; House and Senate chambers are above on the second floor; and the House and Senate galleries are accessible from the third floor. Additionally, the second and third floors contain legislative offices. A central atrium looks upward to the dome. (*Denver Municipal Facts*, Vol. 2, No. 49, December 3, 1910.)

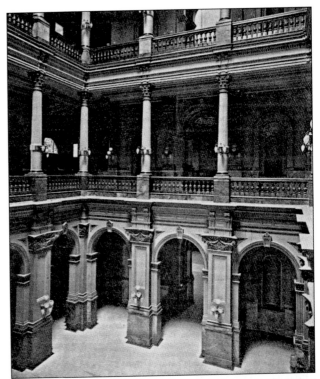

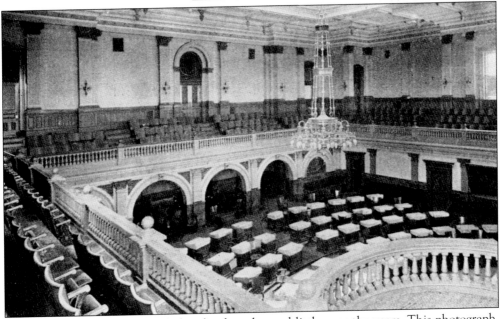

The House of Representatives' chamber has changed little over the years. This photograph, taken from the third-floor gallery, shows the House floor, which looks virtually the same today. In fact, the wooden desks seen here are still in use by today's legislators. One change, however, came with the addition of acoustic tiles in the 1930s, which covered the ceiling's original stencil designs. Another change came with the addition of several Colorado-themed paintings in 1990. (*Denver Municipal Facts*, Vol. 3, No. 1, December 31, 1910.)

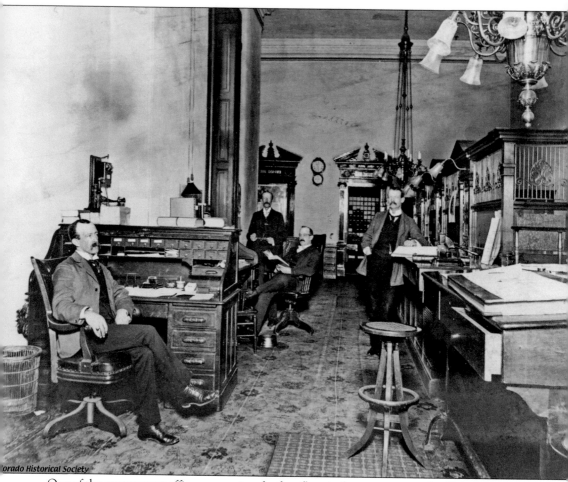

One of the government offices occupying the first floor is the state treasurer's office. Here treasury employees are seen in their office in this c. 1900 photograph. (Colorado Historical Society.)

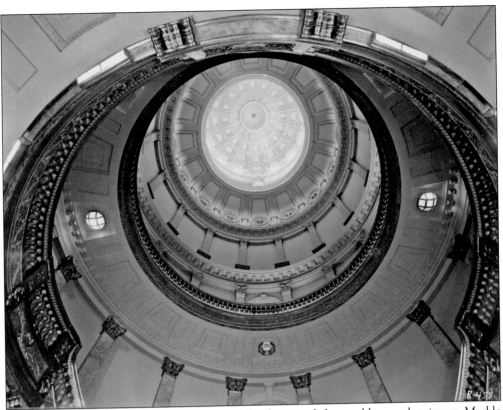

Two of the Capitol's most ornate features are the dome and the marble grand staircase. Marble from Colorado is used throughout the Capitol, including white Yule marble and the distinctive Beulah Red marble from the world's only known deposit of red marble. The quarry was exhausted for the Capitol, so the red marble is irreplaceable. (Both, Colorado Historical Society.)

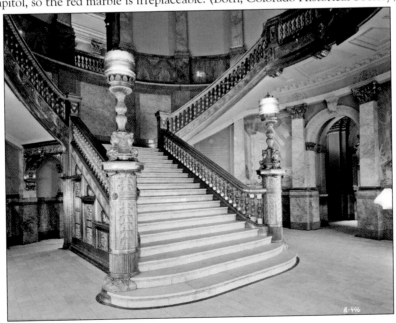

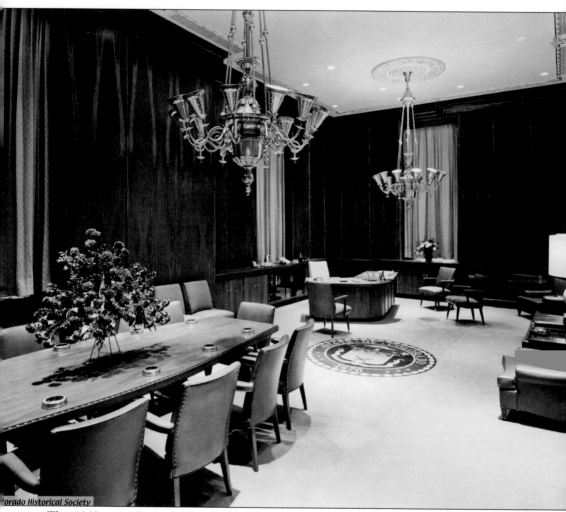

This 1960s view shows the Executive Chambers, located on the first floor, after a 1957 remodel. Prior to that year, employees complained that the governor's office seemed too small and out-of-date. Architect Joseph W. Pahl redesigned the space with walnut paneling, lowered the ceiling, and added a movie screen and color television. Additionally, new offices for the governor's staff were added next to the executive office. (Colorado Historical Society.)

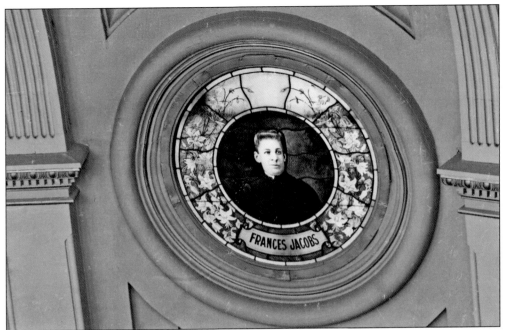

Stained-glass windows throughout the Capitol depict noteworthy Coloradoans. This one, the Capitol's first stained-glass portrait of a woman, features Frances Wisebart Jacobs, who had a Capitol Hill connection. Jacobs, known as "Denver's Mother of Charities," supported the idea of a Jewish consumptive hospital in Denver. This hospital would be built on Capitol Hill at Colfax Avenue and Colorado Boulevard starting in 1892, but Jacobs died that same year, not living to see the hospital to fruition. In her honor, the new hospital bore her name, the Frances Jacobs Hospital. Upon completion of the facility in 1899, it would be renamed National Jewish Hospital and remains today one of the nation's leaders in respiratory care. (Colorado Historical Society.)

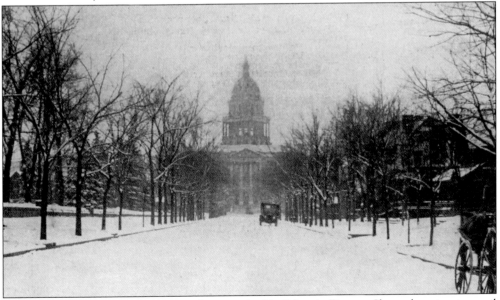

The state capitol is perhaps the most photographed building in Denver. Shown here is a tranquil winter scene. (*Denver Municipal Facts*, Vol. 3, No. 9, February 25, 1911.)

The Capitol steps feature a marker claiming to be exactly 5,280 feet, or one mile, above sea level. The brass marker, placed on the steps in 1909, would keep disappearing as souvenir hunters carved it out of the step. Finally, in the 1940s, the words "ONE MILE ABOVE SEA LEVEL" were carved into the step itself. In 1969, a group of engineering students from Colorado State University discovered that the step was off by about 17 inches. So they placed a new brass marker three steps above the carved step. Both markers remain today. (*Denver Municipal Facts*, Vol. 3, No. 6, February 4, 1911.)

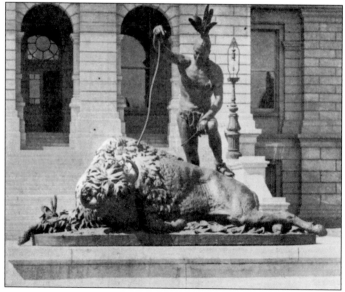

On the east, or Grant Street, side of the Capitol is a statue entitled *The Closing Era*. First exhibited at the World's Columbian Exposition in Chicago in 1893, the statue would be accepted by Colorado's Board of Capitol Managers later that year. The statue, designed by Preston Powers, who had once taught art at the University of Denver, depicts the traditional life of a Native American and his buffalo prey. (*Denver Municipal Facts*, Vol. 1, No. 8, April 10, 1909.)

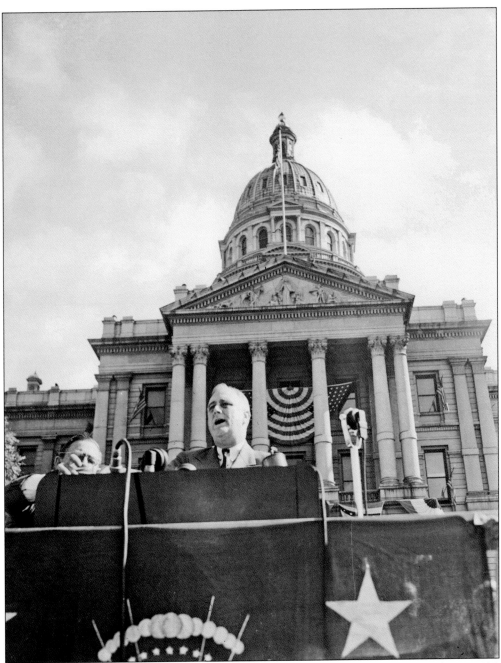

U.S. president Franklin D. Roosevelt delivered a speech on the steps of the Capitol on October 12, 1936. There he talked about the Great Depression's effects on agriculture and mining. "The great but uneven prosperity of the 1920s made us neglect for too long the growing signs that things were not going right with the farmer," he admitted. "Surely by now we have learned that lesson." (Photograph by Harry Rhoads; Denver Public Library Western History Collection.)

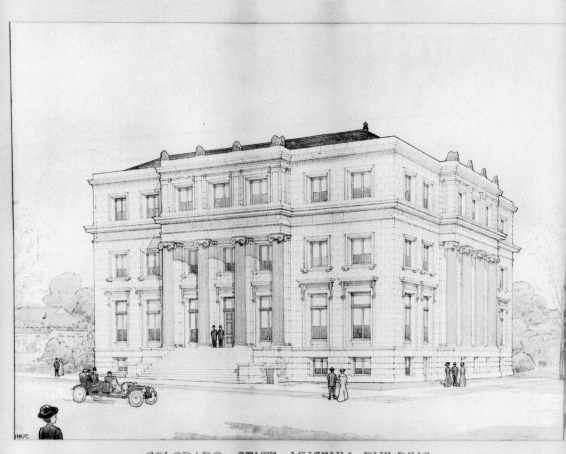

COLORADO STATE MUSEUM BUILDING
DENVER COLORADO

· THE · F. E. EDBROOKE · ARCHITECT · CO ·

Just south of the Capitol stands the structure originally built as the State Museum. The last major project by architect Frank Edbrooke, the museum featured the collections of the forerunner of the Colorado Historical Society, then known as the State Historical and Natural History Society. Completed in 1915, the building features a white neoclassical facade, marble floors, and a marble grand staircase. (Tom Noel Collection.)

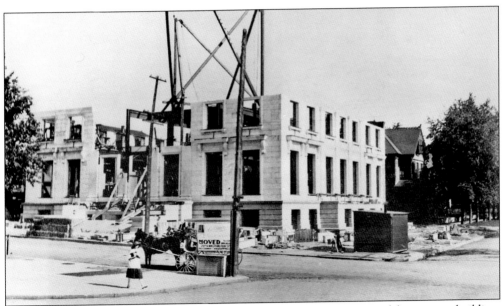

Here the State Museum is shown under construction. Prior to construction of the museum building, the society collections had been exhibited in the Capitol basement. The new building served as a museum until the 1970s, as growing collections required a larger building and more storage space. Since completion of a new, modern structure at Thirteenth Avenue and Broadway, the old museum building has instead housed legislative offices. (Tom Noel Collection.)

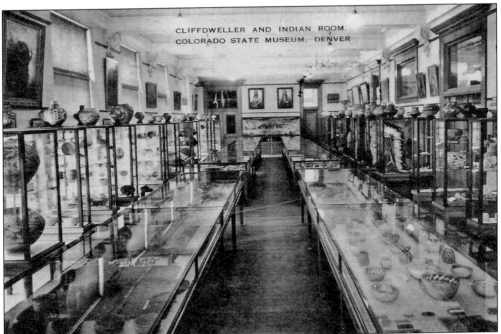

This postcard depicts Native American pottery and artifacts on display in the State Museum. A gentleman writing on the back of this postcard noted the remarkable size of the museum's collections. "A person could spend a day here," he wrote. (Tom Noel Collection.)

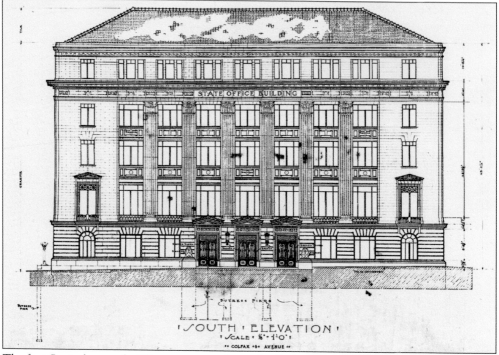

The first Capitol annex building constructed specifically for the purpose of additional office space is the State Office Building at 201 East Colfax Avenue, just north of the Capitol. Built just after the end of World War I in 1919, the building sits on the lot formerly occupied by one of the homes of William Newton Byers, founder of the *Rocky Mountain News*. (Tom Noel Collection.)

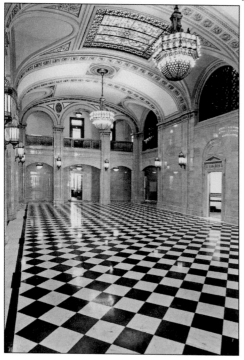

Being the first state offices built outside the Capitol itself, the State Office Building, designed by architect William N. Bowman, closely matches the Capitol in style, though on a much smaller scale. The interior features Yule and Tennessee marble, and an impressive skylight above the interior lobby. Outside, the building is guarded by two bronze mountain lions, the work of sculptor Robert Garrison. Since the 1950s, the building has served as the offices of the Colorado Department of Education. (Photograph by Roger Whitacre; Tom Noel Collection.)

The several blocks of Sherman Street north and south of the Capitol had once been filled with mansions. However, by the 1940s, many of these mansions were being destroyed to build more office structures, such as the Department of Revenue building located south of the Capitol. The annexes on all four corners of the Capitol are connected to the main building via a series of underground tunnels, the first of which was constructed in 1896 for the purpose of coal delivery. (*Colorado Capitol Buildings*, Works Progress Administration, 1951; Colorado State Library.)

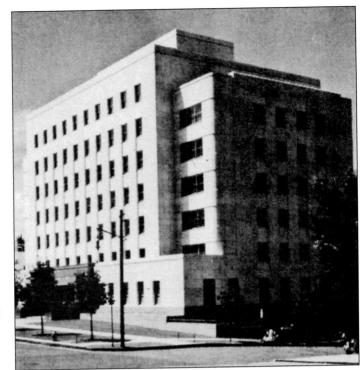

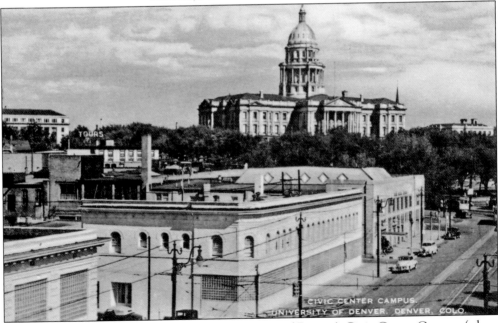

This real-photo postcard, taken from the University of Denver's Civic Center Campus (where the University of Denver's law school held classes), shows the Capitol complex in context. To the far left of the photograph can be seen the State Office Building, while right of the Capitol is the State Museum. The building left of center with the large "Tours" sign on the roof would soon be replaced with a seven-story office building that today houses Colorado's attorney general. (Author's collection.)

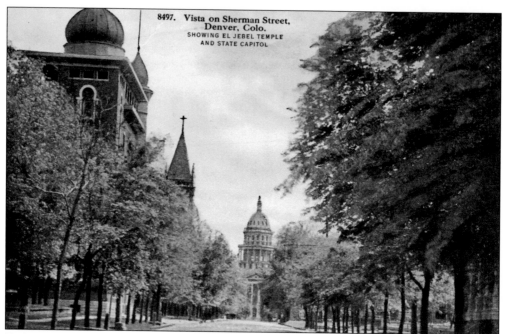

8497. Vista on Sherman Street,
Denver, Colo.
SHOWING EL JEBEL TEMPLE
AND STATE CAPITOL

Earlier postcards, however, show the Capitol before the construction of the other buildings. Looking down toward the Capitol from Eighteenth Avenue, seen here are the El Jebel Temple at Eighteenth and Sherman Streets, the Central Presbyterian Church at Seventeenth Avenue and Sherman Street, and, in the far right corner, the front porch of one of the many long-ago mansions that graced Sherman Street. (Author's collection.)

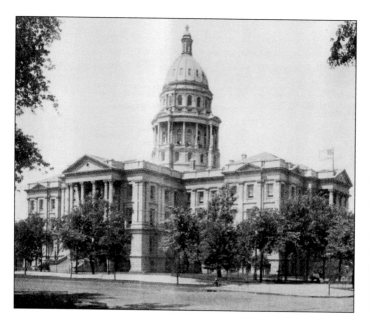

The State Capitol is overseen by a committee appointed by the governor. A major renovation in the early 21st century equipped the building with modern life-safety features while retaining the historic integrity that has made the Capitol one of Colorado's great historic treasures. (*Denver Municipal Facts*, Vol. 2, No. 49, December 3, 1910.)

Two

At Home on Capitol Hill

Denver's earliest houses were clustered around Cherry Creek and Auraria. In the 1870s, after Gov. John Evans built a house at Fourteenth and Arapahoe Streets, wealthy Denverites followed suit, building a Millionaire's Row of impressive Italianate and Second Empire houses along Fourteenth Street. It wouldn't be long, however, until the downtown that had started around today's lower downtown began creeping eastward. Finding their fancy residential enclave being overcome by commercial buildings, Denver's wealthy needed a new Millionaire's Row. When wealthy banker Charles Kountze and railroad financier David Moffat sold their Fourteenth Street mansions for new Queen Annes on Capitol Hill, many of their neighbors followed. The area around the Capitol became the place to be.

As transportation developed, Denver's wealthy no longer needed to live within walking distance of downtown. Old mansions were increasingly converted to offices and apartments before being demolished to build larger apartment structures, office buildings, and parking lots. Those that remain have generally continued as offices or apartments, and a few have returned to single-family use. Still, residents living nearest the Capitol today dwell in apartments and condos instead of mansions. Farther east from the Capitol, most of the smaller, single-family houses remain, giving Capitol Hill a special charm.

After urban renewal in the 1950s and 1960s gutted much of Denver's historic architecture, some residents began to lament this destruction. The 1970s, though still rife with demolitions, saw the emergence of groups like Historic Denver, Inc., which worked to preserve Denver's historic buildings. The Denver Landmark Commission began nominating structures as individual landmarks, while areas retaining many contributing historic structures were designated as Historic Districts. Today Denver boasts more Historic Districts than any other city in the nation, and many of these celebrate the architecture of Capitol Hill.

Yet it is not just architecture that makes these buildings important. These homes all have a story, a rich history that should be preserved. There is no way to show all of the significant homes in Capitol Hill, but this chapter gives a sampling, including both the showplaces of the wealthy and the smaller abodes of the middle class.

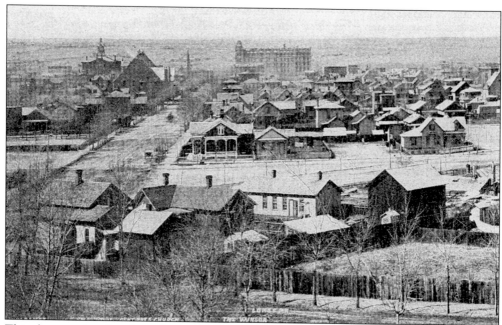

This photograph, taken from about Eighteenth Avenue and Lincoln Street, gives an idea of what Capitol Hill and central downtown looked like in the early 1880s. The diagonal street is Broadway, and the large building in the distance, in the center of the photograph, is the Windsor Hotel at Eighteenth and Larimer Streets. (*Denver Municipal Facts*, Vol. 3, No. 26, June 24, 1911.)

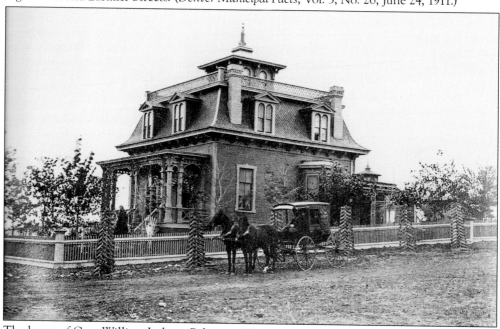

The home of Gen. William Jackson Palmer at Nineteenth Avenue and Lincoln Street is a good example of the type of architecture popular in the 1880s, and some of the earliest houses on Capitol Hill resembled this Second Empire–style home. The owner, General Palmer, is best known as the founder of Colorado Springs but also spent time in Denver, where he served as the president of the Denver and Rio Grande Railroad. (Denver Public Library Western History Collection.)

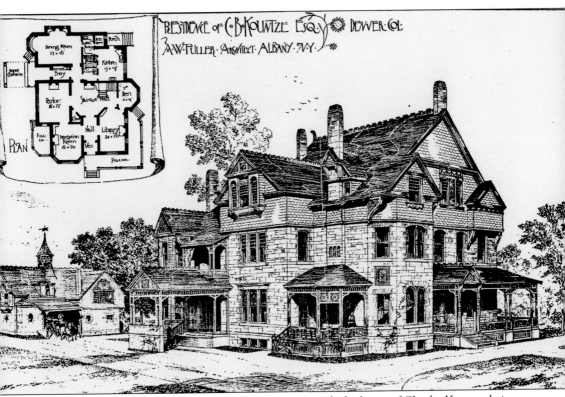

Capitol Hill would soon be known for its grand mansions, with the home of Charles Kountze being the pacesetter. For a time, Kountze, a wealthy banker, lived at Fourteenth and Welton Streets downtown. Before the emergence of Capitol Hill, Fourteenth Street had been Denver's premier residential address. However, as the core downtown expanded and encroached upon the lovely homes, its residents began to vacate. Kountze was one of the first, relocating in 1882 to Sixteenth Avenue and Grant Street on Capitol Hill. There he built one of the grandest mansions in the area, seen here in a drawing by architect A. W. Fuller. The home would be demolished for the Capitol Life Insurance Company building in 1963. Reportedly, the mansion had been so well built that wreckers faced considerable challenges demolishing the structure. (Tom Noel Collection.)

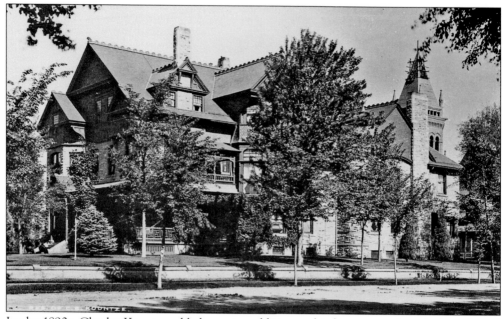

In the 1890s, Charles Kountze added a major addition to his home, seen here in its enlarged state. Behind the home can be seen the Central Presbyterian Church nearing completion. (Tom Noel Collection.)

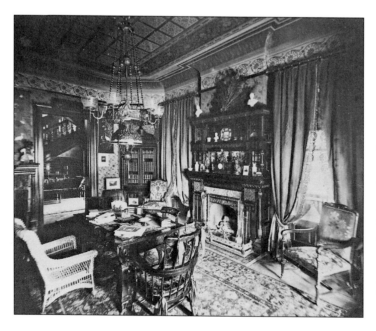

The interior of Kountze's home featured elaborate oak and mahogany woodwork and an impressive Tiffany stained-glass window on the staircase landing. Shown here is the home's elegant parlor. (Denver Public Library Western History Collection.)

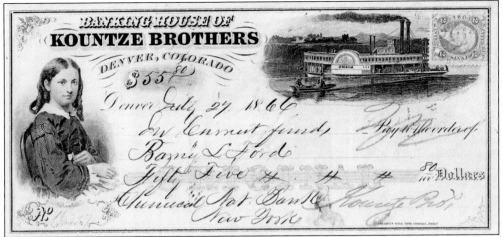

Charles Kountze made his fortune in the banking industry. Arriving in Denver in 1862, Kountze and his brother Luther formed the Kountze Brothers Bank at Fifteenth and Blake Streets. The company evolved into the Colorado National Bank in 1866, and Charles Kountze served as president. Seen here is a bank note from the old Kountze Brothers Bank, made out to Barney Ford, an African American businessman and owner of the Inter-Ocean Hotel, which stood a block north of the Kountze Brothers Bank. (Tom Noel Collection.)

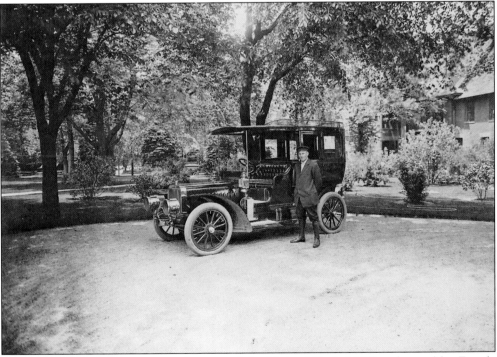

Domestic servants were just as much a part of the fabric of Capitol Hill as the wealthy. Female servants in Capitol Hill's mansions generally lived in the home, usually sleeping on the third floor, while male servants often lived in lofts above the carriage houses. Servants in Denver in the 1890s averaged $20 to $25 per month in salary. Seen here is Charles Kountze's chauffeur, Louis Wecker, with the family's 1907 Pierce Arrow. (Denver Public Library Western History Collection.)

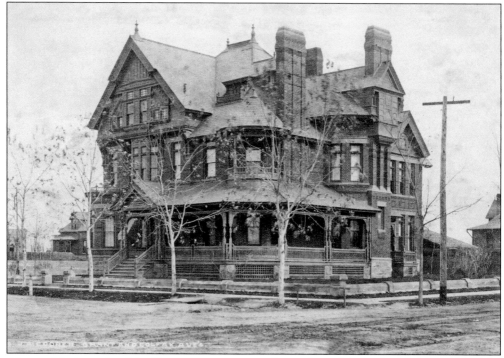

About a block south of the Kountze mansion stands another of the early palaces atop Capitol Hill. This magnificent Queen Anne–style home, belonging to Gov. Job Adams Cooper, sat at the northeast corner of Colfax Avenue and Grant Street, where the Colorado Education Association building stands today. (Denver Public Library Western History Collection.)

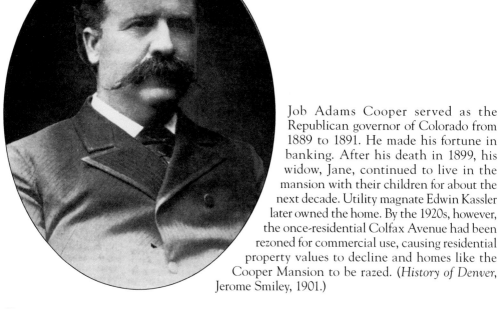

Job Adams Cooper served as the Republican governor of Colorado from 1889 to 1891. He made his fortune in banking. After his death in 1899, his widow, Jane, continued to live in the mansion with their children for about the next decade. Utility magnate Edwin Kassler later owned the home. By the 1920s, however, the once-residential Colfax Avenue had been rezoned for commercial use, causing residential property values to decline and homes like the Cooper Mansion to be razed. (*History of Denver*, Jerome Smiley, 1901.)

Another early mansion belonged to two of Denver's most famous, or perhaps infamous, residents. Horace A. W. Tabor bought this gracious home at Twelfth Avenue and Sherman Street for his bride, Baby Doe. Horace's first wife, Augusta, lived in one of the first Capitol Hill homes, a sweeping estate at Seventeenth Avenue and Broadway. In 1886, Horace and Baby Doe purchased this 1878 home, originally owned by Joseph Bailey, and lived in extravagance—reportedly even keeping live peacocks on the lawn. However, when Tabor lost his fortune with the Panic of 1893, they were forced to abandon their luxurious lifestyle. The house was demolished in 1919. (Tom Noel Collection.)

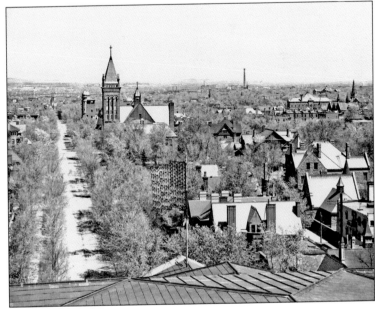

Sherman Street, with its location near the Capitol, had once been a prestigious address. This photograph looks north from the Capitol dome. At right, with the two chimneys and dormer, is the Woodward House. (Denver Public Library Western History Collection.)

Benjamin Woodward made his name as one of the pioneers of Denver's telegraph system. He also served as an elder for Central Presbyterian Church. When his wife, Helen, inherited some property on the east side of Sherman Street just north of the Capitol, she and Benjamin hired architect Frank Edbrooke to design a home for them there. The resulting redbrick-and-sandstone mansion featured many fine appointments, including an elegant stained-glass window, ornate woodwork, bay windows, and marble fireplaces. (*History of Denver*, Jerome Smiley, 1901.)

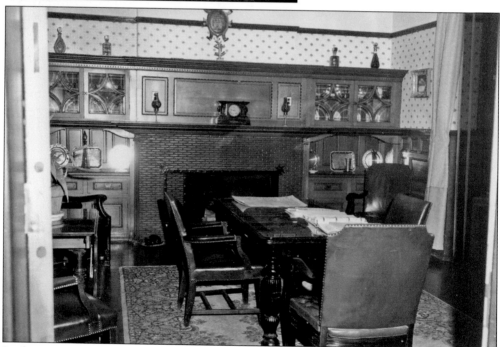

In the 1960s, the Woodward House became the offices of the State Archives after serving for several years as the offices of the Department of Game and Fish. Seen here is the dining room, with its elegant built-in cabinetry, during the time the house served as the archives. By the 1970s, the archives had moved out, and the home sat empty for the next 30 years. (Colorado State Archives.)

Numerous individuals tried to save the deteriorating Woodward House. However, not wanting to give up prime land near the Capitol, the state architect's office, despite an outpouring of protest, demolished the mansion in December 2007. The site is now occupied by an asphalt parking lot. Seen here in its final days, it was the last remaining mansion on Sherman Street north of the Capitol. (Photograph by author.)

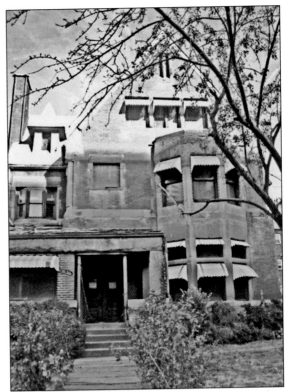

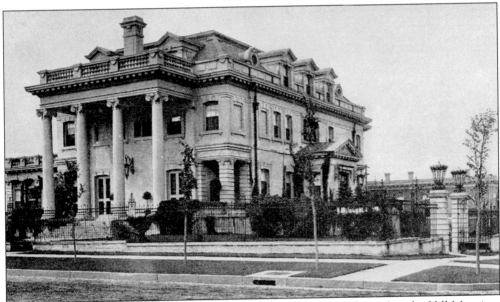

One home on Sherman Street, at the corner of Tenth Avenue, still stands—the Hill Mansion. Architects Boal and Harnois built this 17,000-square-foot showplace in 1904 for Crawford Hill and his wife, Louise. In 1947, the Town Club, a Jewish businessmen's club, purchased the mansion. The members' children enjoyed accompanying their fathers to the mansion, where they could play in the large backyard pool. In 1989, the Town Club dissolved. Sold as office space, the house is now occupied by a large law firm. (*Denver Municipal Facts*, Vol. 3, No. 40, September 30, 1911.)

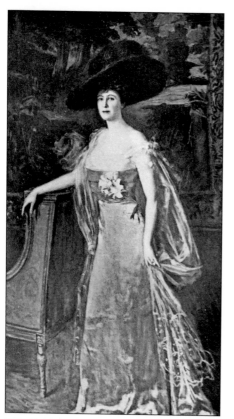

To celebrate her rank as queen of Denver society, Louise Hill commissioned this portrait of herself, painted in an 18th-century style. Hill ruled the exclusive Sacred 36, to which only the highest of Denver Society were invited to belong. (*Representative Women of Colorado*, 1914.)

Louise Hill was famous for her entertaining, as evidenced by the orchestra pit built into her stairway. Hill was also famous for entertaining a certain young gentleman, Bulkley Wells, practically right under her husband's nose. Wells divorced his wife about the time Louise's husband, Crawford Hill, died—but married another woman instead. Furious, Louise allegedly arranged for the loss of Wells's financial investments, leaving him in ruin. He committed suicide in 1931. In the photograph below, Crawford Hill's portrait hangs outside the orchestra pit, while Wells's larger portrait hangs on the wall at left. (Denver Public Library Western History Collection.)

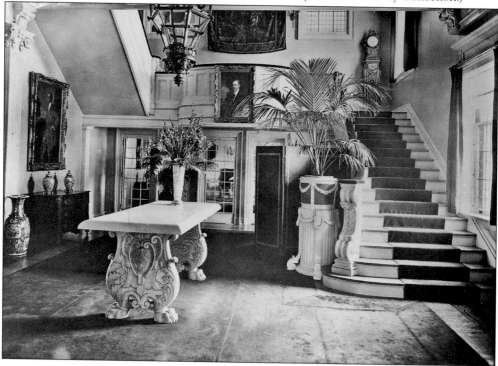

Grant Street, often nicknamed "Gold Street," became a virtual who's who of Denver's wealthy in the late 19th and early 20th centuries. Even the vacant lots befitted a millionaire's row—in an effort to combat unsightly weeds, the city in 1909 planted rye in some lots around Capitol Hill, including this stretch along Grant. (*Denver Municipal Facts*, Vol. 1, No. 23, July 24, 1909.)

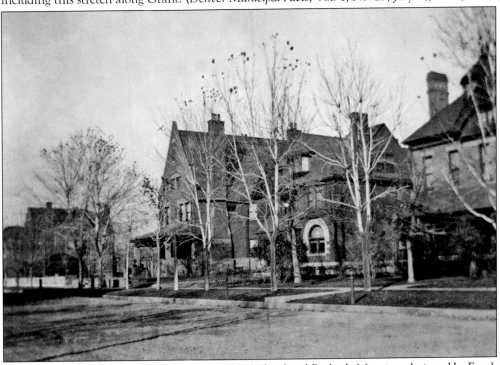

The large house with the peaked roof is the 1889 Whitehead-Peabody Mansion, designed by Frank Edbrooke. William Riddick Whitehead served as a surgeon in the Civil War, where he attended to Gen. Thomas "Stonewall" Jackson after the general's accidental shooting by one of his own men. After the war, the ill health of Whitehead's wife and son led the family west in search of the "climate cure." Landing in Denver, Whitehead set up a successful medical practice. After his death in 1902, his family rented the mansion to Gov. James Peabody. Later uses included a series of restaurants. One of these, Spirits on Grant, capitalized on rumors of ghosts in the mansion. Today the house is offices. (Courtesy of Gary Kleiner.)

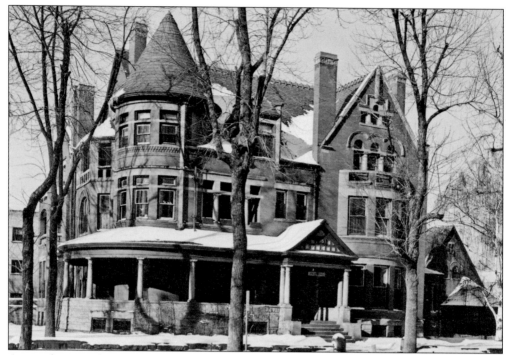

Across the street lived Dennis Sheedy, at the northwest corner of Eleventh Avenue and Grant Street. Sheedy's mansion, which stands today as offices, was the location of two highly publicized social events—the weddings of his daughters. In February 1911, Marie Sheedy, called "the richest girl in Denver," married New Yorker R. L. Livingston in a wedding the *New York Times* called "one of the most fashionable ever held in Denver." Dennis Sheedy surprised his daughter with the gift of a house in New York and a rope of pearls. Four months later, Marie's sister Florence would also marry a New York man, I. Townsend Burden Jr., in her father's home. The Pope himself sent his blessing by underwater telegraph, and the *Times* reported that the gifts totaled $1 million. (Colorado Historical Society.)

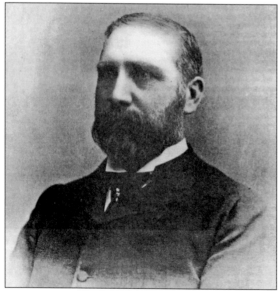

Dennis Sheedy made his millions through various business interests, including mining and banking. He served as president of the Globe Smelting and Refining Company, which established the Globeville area in North Denver. Later Sheedy served as president of the Denver Dry Goods Company. (*History of Denver*, Jerome Smiley, 1901.)

In 1902, David Moffat established the Denver Northwest and Pacific Railway, or "Moffat Road," which was planned as a direct link from Denver to Salt Lake City. However, a major obstacle stood in his way: the Rocky Mountains. Moffat invested heavily in the construction of a tunnel, but debts reaching $9 million left him in ruin. He died in 1911, leaving some to suspect suicide. The tunnel that bears his name would not be completed until 1927. During his life, Moffat had been much admired. In 1904, the legislature presented him with a silver loving cup, supposedly the largest ever made. Today the cup is displayed in the Colorado History Museum. (*Municipal Facts Bi-Monthly*, Vol. 6 No. 8/9, August/September 1923.)

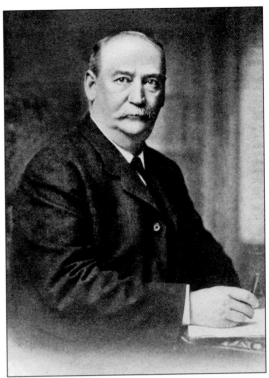

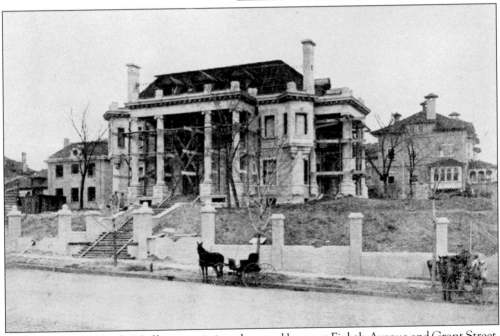

Shortly before his death, Moffat commissioned a grand home at Eighth Avenue and Grant Street, under construction here. Harry J. Manning designed the 33-room palace, featuring a $25,000 Tiffany stained-glass window. Moffat's widow, Fannie, lived in the mansion until 1918. In 1972, following one of the largest preservation battles in Denver history, the mansion was demolished for a box-like office building. (*Denver Municipal Facts*, Vol. 2, No. 6, February 5, 1910.)

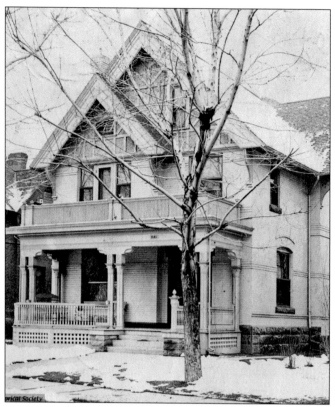

This home at 1151 Logan Street belonged to Jesse McDonald. In 1903–1904, McDonald's neighbor to the west, James Peabody, served as governor. In the 1904 election, Alva Adams emerged as Peabody's opponent. Voters elected Adams, but the candidates traded accusations, alleging bribery and fraud on both sides. A legislative committee decided to remove Adams from office on March 16, 1905, and Peabody would take his place—on the condition that Peabody himself resign by the end of the day. That left the lieutenant governor, McDonald, as governor. Therefore, Colorado has the distinction of having three governors in one day. (Colorado Historical Society.)

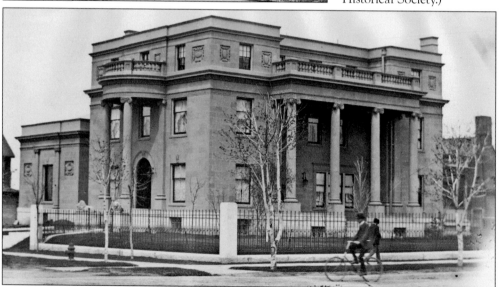

At 1600 Logan Street is the Fisher Mansion, built in 1896. William Garrett Fisher cofounded the Daniels and Fisher department stores. After Fisher accidentally drowned on a fishing trip, his widow continued to live in the mansion, adding a large ballroom and art gallery that can be seen to the left of the main house. Following several owners, the house was purchased by architect David Owen Tryba, who redesigned the ballroom as his studio. (Denver Public Library Western History Collection.)

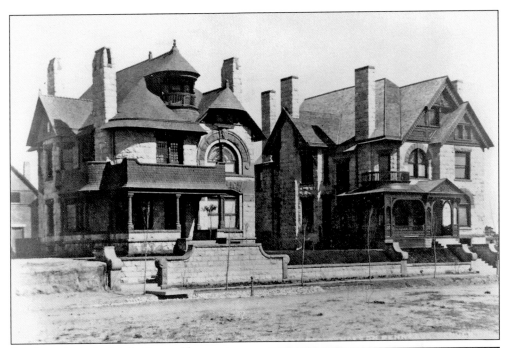

On the right is the Molly Brown House, at Thirteenth Avenue and Pennsylvania Street. Originally built for Isaac and Mary Large, Margaret Brown (who never actually went as Molly in her lifetime) and her husband, J. J., bought the house after moving to Denver from Leadville in 1894. After Margaret's death, the home served various uses, including a home for wayward girls. By the late 1960s, plans were being made to demolish the house. In response, Historic Denver, Inc., worked to save and purchase the building. The Molly Brown House, restored and turned into a museum, is today one of Denver's top tourist attractions. The neighboring house, however, did not fare as well. This home had been built for Joshua Monti, a businessman for whom the Monti Gateway on the east side of City Park is named. After a series of owners, a Baptist church group had the home destroyed in the 1950s. (Denver Public Library Western History Collection.)

Molly Brown is best known as a heroine of the *Titanic*, and though she may have had her eccentricities, her character was greatly embellished for the plays and movies written about her life. (*Representative Women of Colorado*, 1914.)

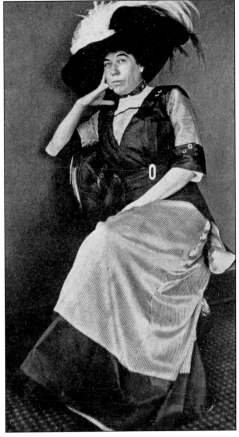

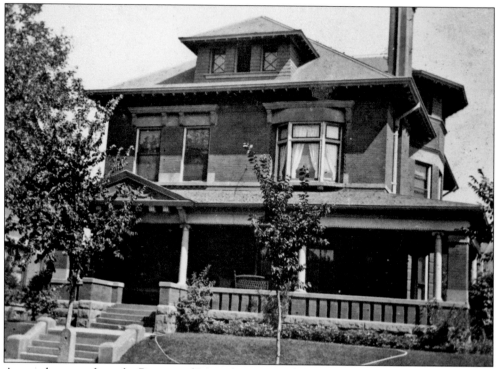

Across the street from the Brown and Monti houses stood the home of John Milheim, a native of Switzerland who had opened Denver's first bakery. In the 1980s, the Colorado State Employees Credit Union sought to build on the site. In response to preservationists' outcry, the credit union offered to give the house away—on condition that it be moved. Real-estate businessman Ralph J. Heronema and his partner, James Alleman, acquired the house and arranged to move it to an empty lot at the corner of Colfax Avenue and Race Street. With the help of city councilwoman Cathy Donohue, power lines along Colfax were buried and stoplights temporarily unstrung for the mansion's half-mile trip up Colfax. This photograph offers a rare view of the house in its original location on Pennsylvania Street. (Colorado Historical Society.)

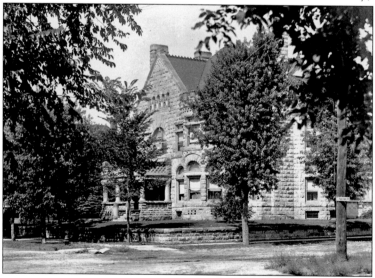

At the corner of Twelfth Avenue and Pennsylvania Street stood this stone castle, designed by William Lang. The house originally belonged to banker Walter Dunning, who sold it to lawyer and state Supreme Court judge Mitchell Benedict in 1898. (Tom Noel Collection.)

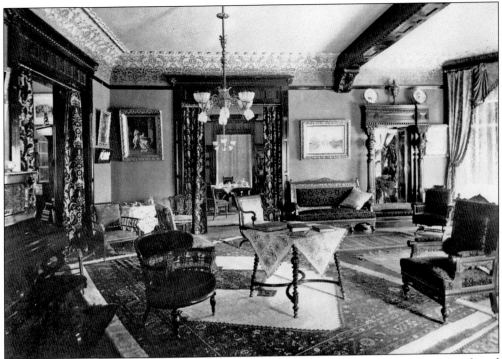

These 1899 photographs show the Benedicts' richly appointed drawing room and library. Purchased and restored by a Denver real estate developer in 1966, the mansion stands today as apartments. (Both, Tom Noel Collection.)

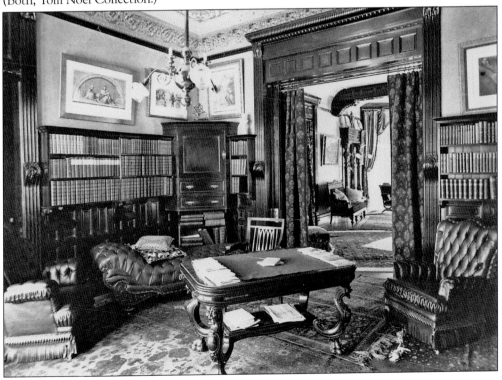

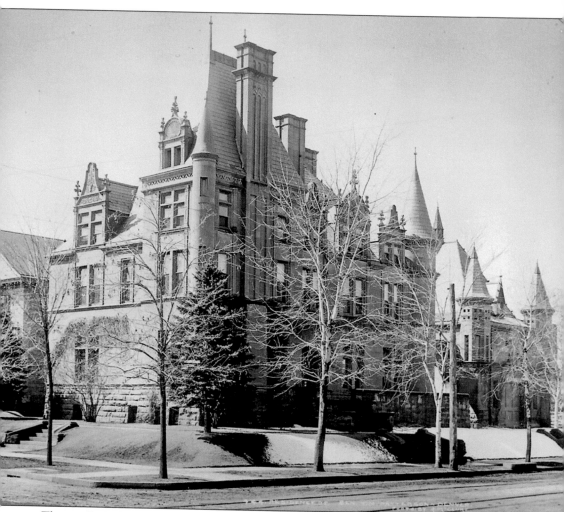

Thomas B. Croke built one of Capitol Hill's most magnificent mansions at the southwest corner of Eleventh Avenue and Pennsylvania Street. An upholstery store owner and irrigation developer, Croke did not live there long, preferring a less ostentatious dwelling after the deaths of both his mother, Catherine, and his young wife, Margaret Dumphy Croke. In 1893, Croke sold the mansion to Thomas M. Patterson, lawyer, U.S. senator, and owner of the *Rocky Mountain News* and *Denver Times*. The mansion, designed by architect Isaac Hodgson, is based on the 16th-century Chateau Azay-le-Rideau in France's Loire Valley. Built in 1891, the Croke-Patterson-Campbell Mansion is the best surviving example of Chateauesque-style architecture in Denver. (Photograph by Louis McClure; Denver Public Library Western History Collection.)

After settling in Denver in 1872 and setting up a promising law practice, Thomas Patterson was elected a territorial delegate to Washington. A Democrat, Patterson played a key role in helping Colorado achieve statehood in 1876—but the addition of the Republican-leaning state's electoral vote handed the presidency to Republican Rutherford B. Hayes. Patterson later served in the U.S. House of Representatives from 1877 to 1879 and in the U.S. Senate from 1901 to 1907. In 1890, Patterson acquired the *Rocky Mountain News*, which he used as his personal political organ. There he exposed the corruption of his rival newspaper publisher, Fred Bonfils of the *Denver Post*. Bonfils retaliated one morning by physically attacking Patterson at Fourteenth Avenue and Logan Street as the aging senator walked to work. Patterson sold the *News* in 1913 and died in the mansion three years later. (Archives, University of Colorado at Boulder.)

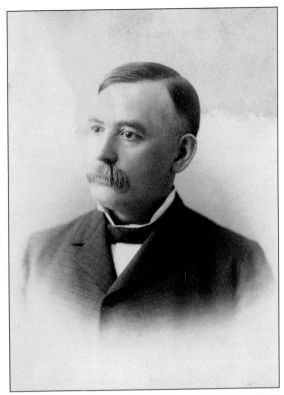

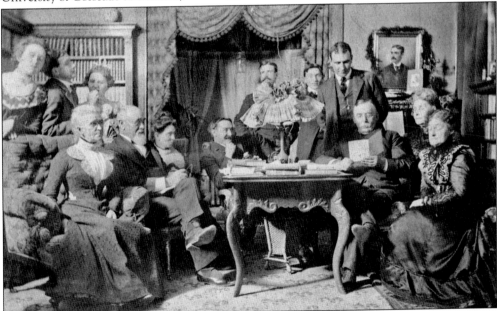

This photograph shows Patterson in the library of the mansion. Beside him, with eyes closed, is his wife, Katherine. When her husband purchased the Croke mansion, Katherine and their children had been visiting family in Boston. In a letter dated February 4, 1893, Patterson wrote of his purchase, "I hope you like it. I think you will. I know the girls will. Now, if your breath's not taken away, what do you say?" (Archives, University of Colorado at Boulder.)

After Patterson's death, his only surviving child, Margaret, and her husband, Richard Campbell, inherited the mansion. Margaret and Richard had been married in the mansion's library. In this photograph, Margaret stands on the staircase. Known for her charity work, Margaret had studied in Europe, attended East High School, and graduated with honors from Bryn Mawr College. She served as a charter member of the Denver Woman's Press Club, whose headquarters are still located on Capitol Hill at Thirteenth Avenue and Logan Street. Margaret died in 1929. (Archives, University of Colorado at Boulder.)

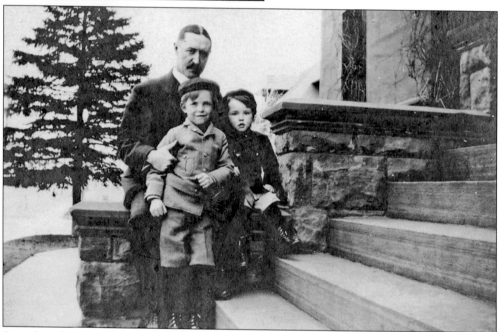

Seated on the steps of the Croke-Patterson-Campbell Mansion are Margaret's husband, Richard Campbell, and the couple's two sons, Thomas (left) and Richard. (They also had a daughter, Katherine, not pictured.) The older son, Thomas Patterson Campbell, would go on to obtain a doctorate in metallurgy from the Colorado School of Mines and served as Denver's manager of Parks and Improvements from 1947 to 1955. He and his wife, Miriam, made their home at 840 Gaylord Street in Capitol Hill. (Archives, University of Colorado at Boulder.)

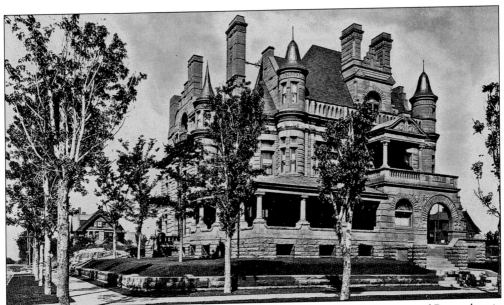

Architect Isaac Hodgson also designed this marvelous chateau at Tenth Avenue and Pennsylvania Street, just a block away from the Croke-Patterson-Campbell Mansion. Built for railroad surveyor John McMurtrie, the home was later sold to brewer John Good and his wife, Rosalie. The home would later be converted to apartments, known as the Castle Leigh. Fred Zint, a former Denver General Hospital employee who lived in the Castle Leigh in the 1950s, fondly remembers living in the mansion, for which he paid just $75 a month in rent. After moving to Ohio, Zint was dismayed to find, on a return trip to Denver, that the mansion was gone. It had been demolished in 1965. (Tom Noel Collection.)

A block away, at 900 Pennsylvania Street, stood the Church-Willcox Mansion. Charles MacAllister Willcox, who purchased the mansion in 1917, served as general manager of the Daniels and Fisher department store and oversaw construction of the famous D&F Tower in 1911. Willcox died in 1932, and his widow continued to live in the now-demolished mansion until her death in 1961. (*Denver Municipal Facts,* Vol. 9, No. 5/6/7, May/June/July 1926.)

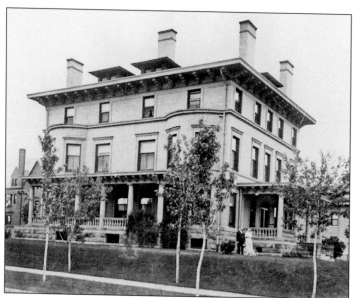

John Kernan Mullen, owner of several flour mills and the J. K. Mullen Land and Cattle Company, built this home at 896 Pennsylvania Street. Mullen also gave generously to philanthropic causes. Visible in this photograph are Mullen and his wife, Catherine. The house has since been demolished. (Denver Public Library Western History Collection.)

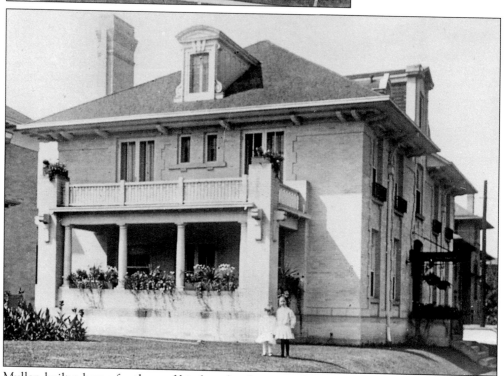

Mullen built a home for three of his four daughters nearby his own. This French-style home, at 450 East Ninth Avenue, was for his daughter Ella, who married Eugene Weckbaugh. Shown here are their children, Eleanore and John Kernan Weckbaugh. The Weckbaughs later moved to an enormous estate at 1701 East Cedar Avenue. The Ninth Avenue home eventually served as the Italian Consulate in Denver. Ella's sister May had married Frank Tettemer, living at 875 Pennsylvania Street. After Tettemer's death, May moved back in with her parents, eventually remarrying to John Dower. Another sister, Katherine Mullen O'Connor, lived at 860 Pennsylvania Street. (Tom Noel Collection.)

The youngest Mullen sister, Edith, married Oscar Malo. At first, they lived in May's house after Edith's widowed sister moved back in with her parents. Eventually, in 1921, the Malos built this lovely Spanish Colonial Revival–style home at Eighth Avenue and Pennsylvania Street. Today the home is used as offices. (*Denver Municipal Facts*, Vol. 9, No. 5/6/7, May/June/July 1926.)

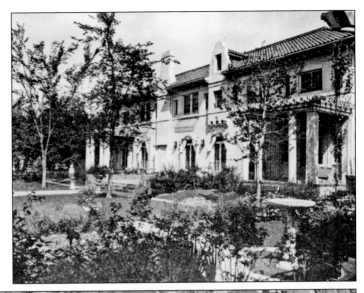

The large structure in the lower left of this photograph is the Grant-Humphreys Mansion at 770 Pennsylvania Street. Designed by architects Boal and Harnois, the 42-room mansion with its own basement ballroom/theater, complete with stage, was built for former governor James Benton Grant and his wife, Mary Goodell Grant. Mining tycoon A. E. Humphreys Sr. purchased the mansion in 1917. Today it is owned by the Colorado Historical Society, and the mansion, still with some of its original furniture, is a popular location for weddings. The large house just above the Grant-Humphreys Mansion, with the rounded porch, is the Foster-McCauley-Symes House at 738 Pearl Street, which was built for investment banker Alexis Foster. (Denver Public Library Western History Collection.)

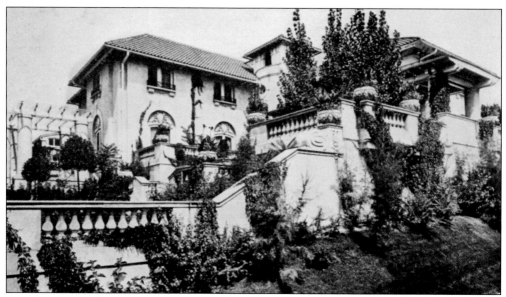

Another gem of the Seventh Avenue Historic District is the Wood-Morris-Bonfils Mansion at 707 Washington Street. Built for mining and railroad investor Guilford S. Wood, the home was sold to railroad businessman P. Randolph Morris in 1923. In 1947, Morris's widow sold the mansion to Helen Bonfils and her husband, George Somnes. Bonfils's father, Frederick, had been owner of the *Denver Post*, which Helen inherited after his death. Helen's main interest, beside the *Post*, was theater, and she and Somnes produced several plays together. When he died, the lonely Helen married her much younger chauffeur, "Tiger Mike" Davis, who spent Helen's money in Las Vegas and conducted an affair with Phylis McGuire of the McGuire Sisters. After they divorced, the house sat empty for several years. Subsequent uses have included condominiums and the home of the Mexican Consulate. (*Denver Municipal Facts*, Vol. 3, No. 40, September 30, 1911.)

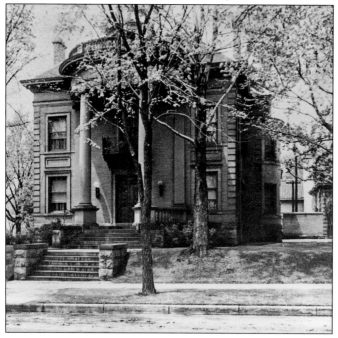

At the corner of Seventh Avenue and Clarkson Street stands the imposing Zang Mansion, built in 1902. Adolph Zang managed the Zang Brewery, which his father, Philip, had purchased and which father and son together built into one of the largest breweries west of the Mississippi. Adolph Zang also invested in mining and ran the Zang Realty and Investment Company, responsible for the Oxford Hotel downtown. Today his home, now offices, retains many of its original furnishings, light fixtures, and stained- and painted-glass windows. (Rod Greiner.)

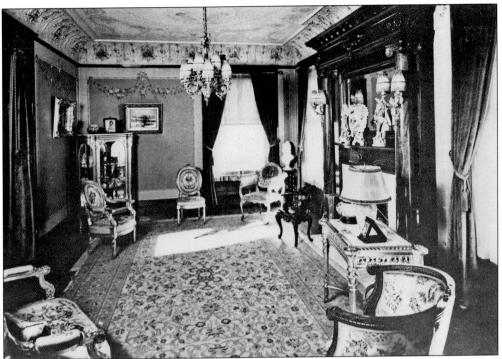

Two views of the main parlor are shown in these photographs. The painted wall coverings still grace this room, which is like stepping back in time. Portraits of the Zang daughters hang on the wall in the image below. (Both, Rod Greiner.)

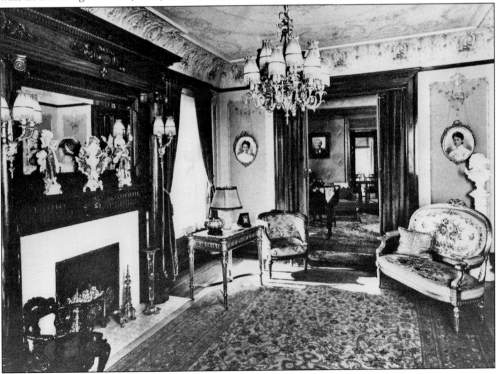

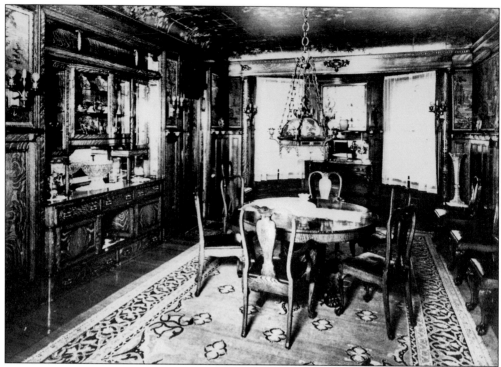

More interior views of the Zang mansion include the dining room, which still retains its original table and chairs, chandelier, and built-in buffet. The sitting room features a painted-glass window depicting Romeo and Juliet. (Both, Rod Greiner.)

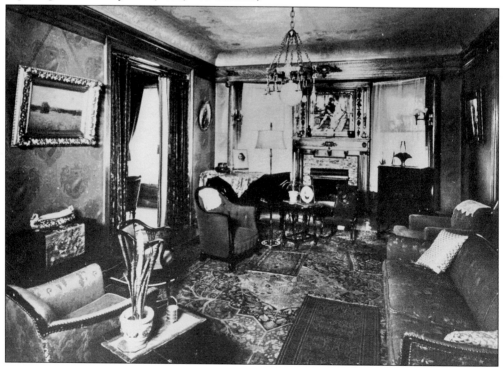

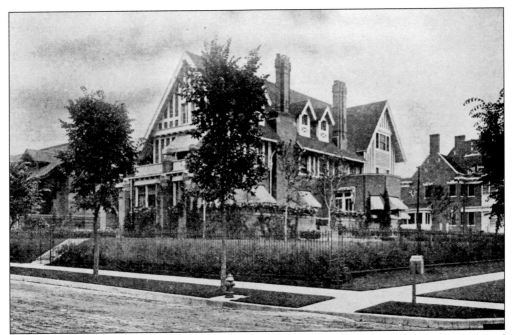

Built in 1908 for Benjamin Ray, this home at Seventh Avenue and Emerson Street was purchased by attorney Joel Vaile in 1913. The following year, Vaile, a widower, married Anna Wolcott, whose brothers had been Vaile's business partners. Anna Wolcott served as headmistress of Capitol Hill's famous Wolcott School. (*Denver Municipal Facts*, Vol. 3, No. 31, July 29, 1911.)

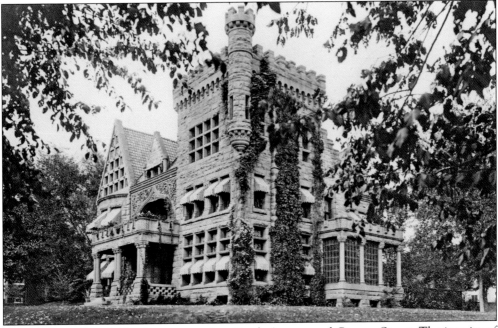

The William Church Castle once stood at Tenth Avenue and Corona Street. The interior of the castle featured Moorish designs and red hand-tooled leather carving on the walls. The home even had its own pipe organ. Later the mansion was converted into a guest house before being demolished in 1965. (Colorado Historical Society.)

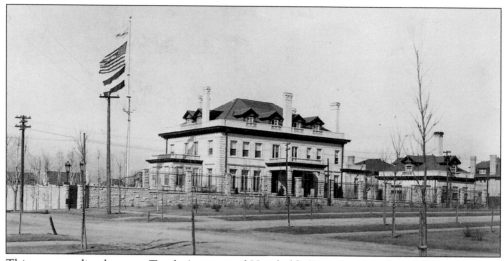

This commanding home at Tenth Avenue and Humboldt Street on the edge of Cheesman Park is the Stoiberhof, so named because it originally housed a most colorful character, Lena Stoiber. Lena had been married four times, including to Hugh Rood, a Washington state lumberman who supposedly went down with the *Titanic*. Lena refused to accept Rood's death, holding séances in the hope of answers. A woman of expensive tastes and one of Louise Hill's Sacred 36, Lena preferred Europe to Denver. She sold the mansion to millionaire businessman Verner Z. Reed, who had made a fortune investing in real estate, mining, and oil. The mansion has continued as a private residence ever since. (Photograph by Charles S. Price; Denver Public Library Western History Collection.)

Verner's wife, Mary, devoted herself to philanthropic causes, including the establishment of the Margery Reed Mayo Day Nursery at Twenty-eighth and Lawrence Streets, named for her daughter, and the Mary Reed Library at the University of Denver. Mary lived in the Humboldt Street mansion before moving to a large estate on Circle Drive in the Denver Country Club in the 1930s. The huge home she built there is the finest example of Tudor Revival architecture in Denver, and its massive chimneys can be seen from blocks away. (*Representative Women of Colorado*, 1914.)

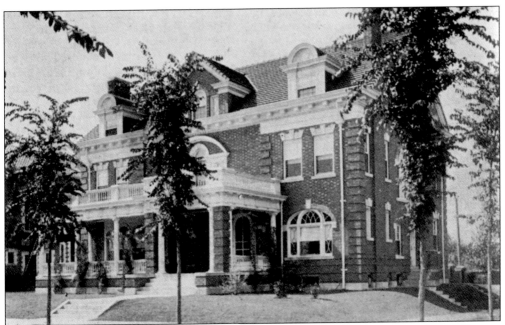

Down the block from Stoiberhof lived Gov. William Sweet in this 1906 Georgian Revival house. Serving as governor from 1922 to 1924, Sweet lost his bid for reelection because of his opposition to the Ku Klux Klan, which had a large following and immense political power in Denver at that time. The Sweet House, Stoiberhof, and the other mansions on the block make up the Humboldt Island Historic District, Denver's second designated historic district after Larimer Square. (*Denver Municipal Facts*, Vol. 1, No. 35, October 16, 1909.)

Also bordering Cheesman Park, at 1200 Williams Street, is the Tears-McFarlane House. The family of railroad attorney Daniel Tears occupied the house until 1938, when it was sold to Frederick and Ida Kruse McFarlane. Ida played a role in preserving the Central City Opera House and also taught English at the University of Denver. Today the home is a community center owned by the Capitol Hill United Neighborhoods (CHUN), which has its headquarters there. (*Denver Municipal Facts*, Vol. 2, No. 21, May 21, 1910.)

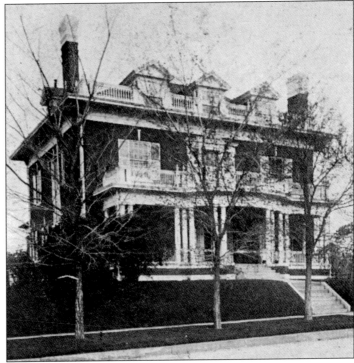

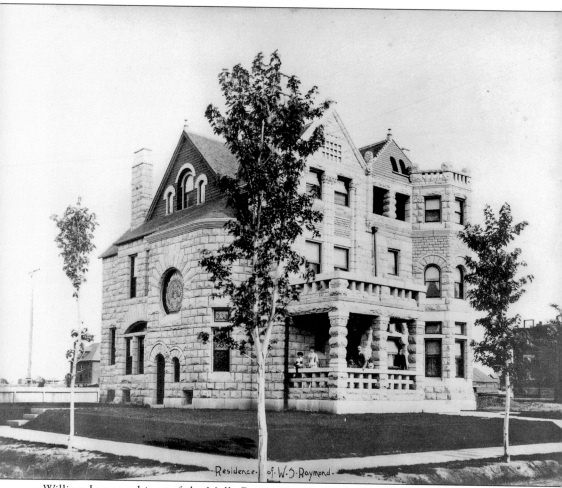

·Residence· of·W·S·Raymond·

William Lang, architect of the Molly Brown House and the Dunning-Benedict Mansion, also designed the Raymond House, known today as the Castle Marne, 1572 Race Street. Wilbur S. Raymond, a real estate developer, commissioned the house in 1890. One of a series of subsequent owners was Adele Van Cise, a widow whose husband, Edwin, and son, Philip, were attorneys famous for fighting corruption in Denver. Philip wrote *Fighting the Underworld*, a book describing his efforts against Lou Blonger and other criminals. His mother, Adele, divided the house into apartments in 1918, naming the building the Marne Apartments after the World War I battle where her son had fought. In 1989, Jim and Diane Peiker bought the house, lovingly restoring the home and establishing a popular bed-and-breakfast, the Castle Marne, which allows visitors to step back in time in this Victorian masterpiece. (Denver Public Library Western History Collection.)

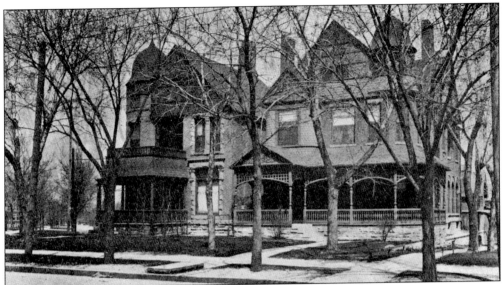

Park Avenue is the only street that cuts a diagonal through Capitol Hill. It was platted in 1874 as a greenbelt parkway, a popular concept during the City Beautiful movement. However, this plan never came to fruition, and Park Avenue was developed just like any other street. By 1912, city planners decided that Park Avenue should become a traffic arterial, connecting with Colfax Avenue. As a result, these two mansions at Franklin Street and Park Avenue had to be destroyed. *Denver Municipal Facts* snapped this photograph of the two doomed mansions just before their destruction. (*Denver Municipal Facts*, Vol. 4, No. 18, May 4, 1912.)

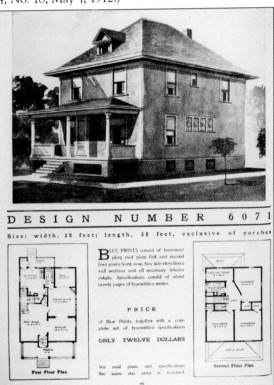

After the Panic of 1893, architectural styles changed. Out were the turreted, gingerbreaded Queen Annes. Instead, simpler styles were favored. Middle-class houses were often built in the Foursquare style, seen here. Foursquares became so popular in Denver that they are now more often referred to as Denver Squares. This 1909 plan by the Radford Architectural Company featured a typical design. (Denver Public Library Western History Collection.)

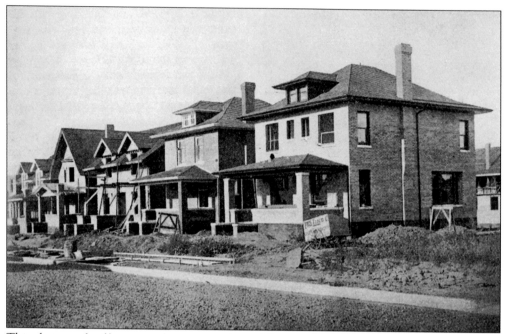

This photograph of houses under construction at Thirteenth Avenue and Fillmore Street shows the popularity of the Foursquare and other similar designs. Foursquares were symmetrical with a door and window on the first floor and two widows directly above. (*Denver Municipal Facts*, Vol. 1, No. 27, August 21, 1909.)

The block between Twelfth and Thirteenth Avenues on St. Paul Street in the Congress Park area illustrates a typical Capitol Hill residential street. Most of the homes on this block date from the first two decades of the 20th century, and many Capitol Hill blocks still look similar today. (*Denver Municipal Facts*, Vol. 3, No. 38, September 16, 1911.)

Not all Denver Squares look the same. Many homeowners tried to individualize their Foursquares with various types of ornamentation. Shown here are two embellished Foursquares, the Connor House at 765 Corona Street (pictured above) and the Nast House at 1335 Milwaukee Street (shown below). (*Denver Municipal Facts*, above Vol. 3, No. 2, January 7, 1911; below Vol. 4, No. 34, August 31, 1912.)

An unusual example of what the *Denver Municipal Facts* called the Scottish style can be seen in the McPhee House at Eighth Avenue and Washington Street. (*Denver Municipal Facts*, Vol. 2, No. 32, August 6, 1910.)

Also interesting architecturally is the W. H. Smiley House at 1115 Race Street, which exhibits some Frank Lloyd Wright influences. (*Denver Municipal Facts*, Vol. 3, No. 33, August 12, 1911.)

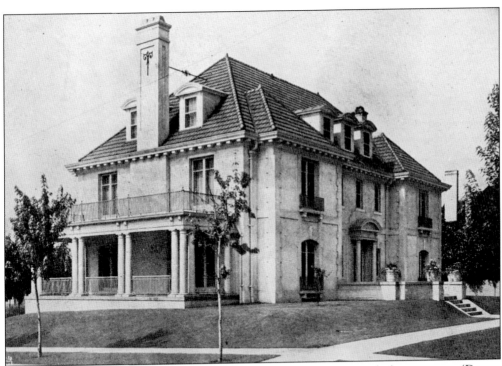

The home of J. M. Kuykendall at 930 East Seventh Avenue is built of white cement. (*Denver Municipal Facts*, Vol. 3, No. 33, August 12, 1911.)

As architectural styles changed and Capitol Hill continued to grow, *Denver Municipal Facts* in 1911 remarked on this remnant from an earlier era, the tiny frame cottage of H. L. Baldwin at 1230 Logan Street, which had somehow managed to hang on despite the area's prime real estate in the 1890s, as mansions were built up around it. (Photograph by Louis McClure; *Denver Municipal Facts*, Vol. 3, No. 33, August 12, 1911.)

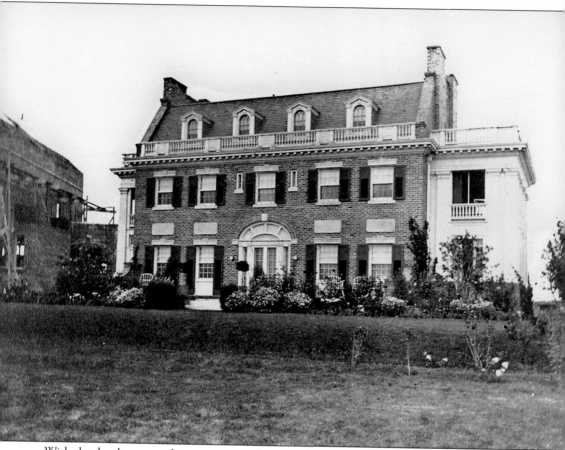

With the development of transportation, living within walking distance of the state capitol or of downtown was no longer seen as desirable. Instead, by the 1920s, attitudes had changed so that a more prestigious address was one farther from the Capitol. Such an address announced that not only could one afford to live away from the dirt and grime of the city, but could also probably afford an automobile as well. Even as the wealthy abandoned older parts of Capitol Hill, other areas, such as Cheesman Park and Morgan's Addition, remained desirable. Shown here is the Livermore-Benton House at 901 Race Street in the Morgan's Addition area, which stretches along Eighth and Ninth Avenues from Cheesman Park to Josephine Street. The Colonial Revival–style home was designed by architect Maurice Biscoe. (Tom Noel Collection.)

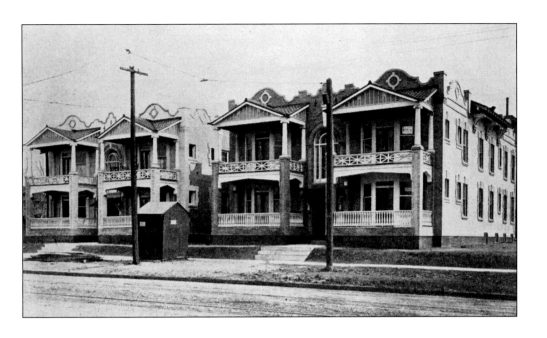

Capitol Hill is by no means a neighborhood only for the rich. Despite many grand homes throughout the neighborhood, much of Capitol Hill consists of modest dwellings, including bungalows, cottages, Foursquares, and many apartment buildings. These buildings, at Seventeenth Avenue and York Street (pictured above) and Seventeenth Avenue and Steele Street (shown below), illustrate the type of apartment buildings common in the early part of the 20th century in Capitol Hill. (Both, *Denver Municipal Facts*, Vol. 3, No. 18, April 29, 1911.)

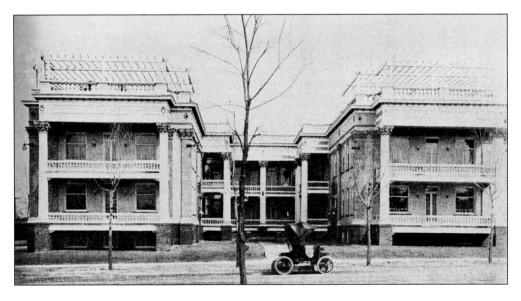

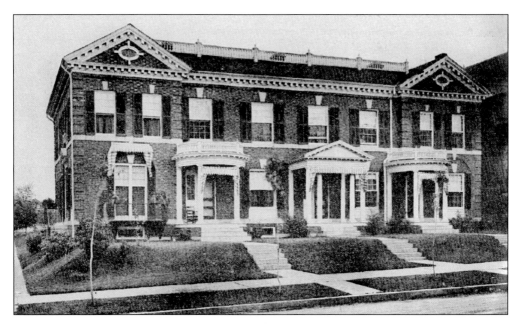

The Georgian, Colonial, and Classical Revival styles popular in many of the city's mansions after the beginning of the 20th century were also adapted to apartment buildings, such as these at the corner of Fourteenth Avenue and Franklin Street (pictured above), which still stands, and at Twelfth Avenue and Lincoln Street (shown below), which has been demolished. (*Denver Municipal Facts*, above Vol. 3, No. 31, July 29, 1911; below Vol. 4, No. 3, January 20, 1912.)

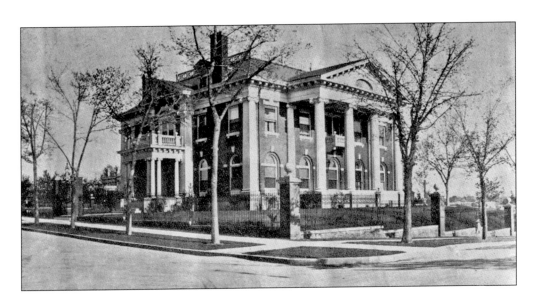

Over time, Capitol Hill's mansions experienced very different fates. The Cheesman-Boettcher Mansion is one of the lucky ones. Utility magnate Walter S. Cheesman commissioned the mansion in 1907 but died before its completion in the Dunning-Benedict Mansion, which he had been renting. His widow, Alice, and daughter, Gladys, lived in their new mansion at Eighth Avenue and Logan Street until selling it to Claude Boettcher, who gave the deed to his wife, Edna, for a Valentine's Day gift in 1923. (*Denver Municipal Facts*, above Vol. 2, No. 23, June 4, 1910; below Vol. 1, No. 24, July 31, 1909.)

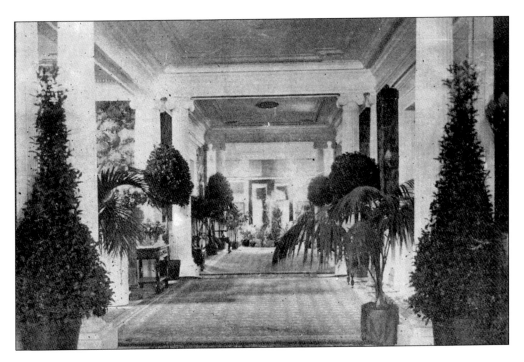

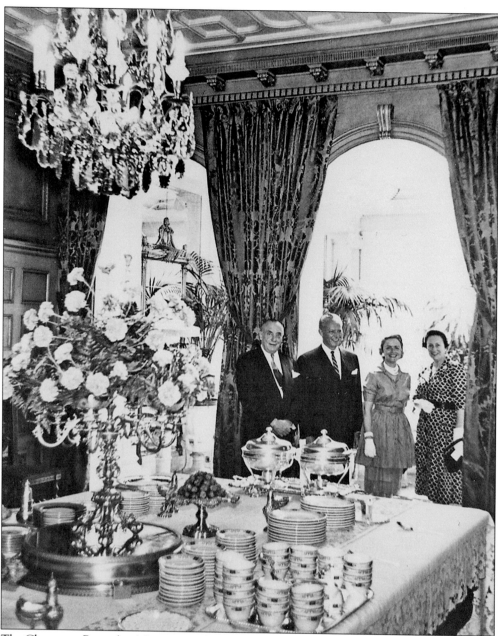

The Cheesman-Boettcher Mansion was built for entertaining, which the Boettchers did lavishly. The home features elegant furniture, a large drawing room and dining room, and one of the home's finest features, the Palm Room at the back of the house. Supposedly, lighting could be changed to match Edna Boettcher's gowns. The Boettchers continued to live in the mansion until their deaths in 1957 and 1958, when the home was passed to the Boettcher Foundation with the idea that it would be donated to the state for a governor's mansion. This idea was not without its opponents, and the home came perilously close to being torn down. However, the home had a supporter in Gov. Stephen McNichols, who had grown up nearby. At his urging, the state accepted the mansion in 1959. Seen here are Gov. and Mrs. Stephen McNichols, flanked by Claude's son, Charles Boettcher II, and his wife. (Colorado Historical Society.)

Another house that escaped demolition is the home of Richard H. Hart. Originally at 2001 East Eleventh Avenue at Race Street, the home was moved to Twelfth Avenue and Humboldt Street in 1981. (Photograph by Roger Whitacre; Tom Noel Collection.)

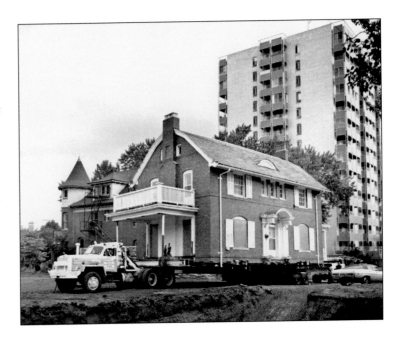

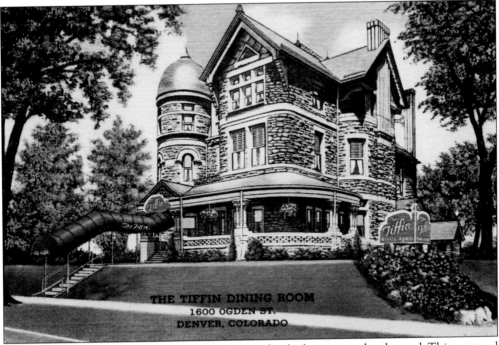

THE TIFFIN DINING ROOM
1600 OGDEN ST.
DENVER, COLORADO

Sometimes Capitol Hill mansions became famous for the businesses they housed. This postcard shows the Bailey Mansion at 1600 Ogden Street when it served as the Tiffin Dining Room, a well-known and award-winning Denver restaurant. Later the home-then-restaurant was converted to law offices. It is among the most beautifully restored mansions in Capitol Hill. (Author's collection.)

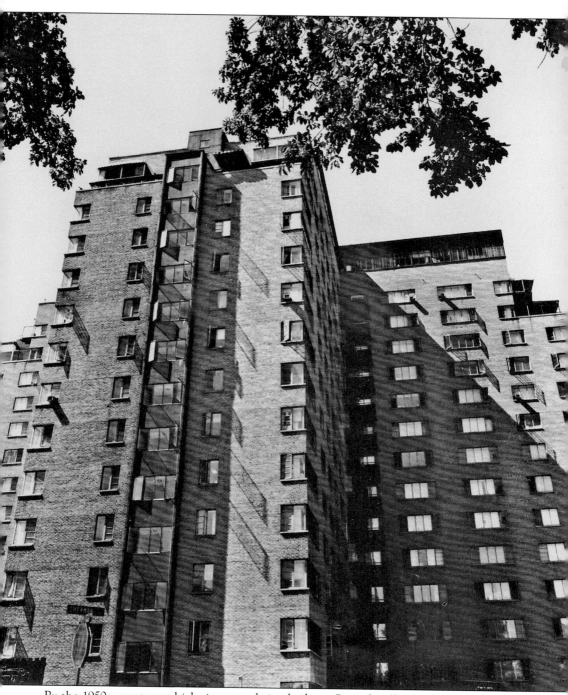

By the 1950s, apartment high-rises were being built on Capitol Hill. The first was the 14-story Sherman Plaza at 901 Sherman Street. These high-rises mixed in with historic buildings, making Capitol Hill a unique stew of architectural styles and periods. (Tom Noel Collection.)

Three

MIND, BODY, AND SPIRIT

Capitol Hill is much more than just houses. It is a true neighborhood, and Capitol Hill's numerous schools, hospitals, and places of worship illustrate a strong sense of community.

Before a school was built on Capitol Hill, area children attended the Broadway School just outside Capitol Hill at Thirteenth Avenue and Broadway. Soon, however, the Emerson School at Fourteenth Avenue and Ogden Street would be built, followed by the Corona (now Dora Moore) School at Ninth Avenue and Corona Street; the Wyman School at Sixteenth Avenue and Williams Street; the Stevens School at Eleventh Avenue and Columbine Street; and the Teller School at Eleventh Avenue and Garfield Street. Gove and Morey Junior Highs and East High School would educate older students. Private academies also catered to the area's wealthy.

Most of the city's hospitals are within the Capitol Hill boundaries, including several along Capitol Hill's northern edge. These institutions sprang from a desire to aid the helpless, including children and poverty-stricken consumptives.

Capitol Hill has also boasted around two dozen churches and synagogues. Although a few of these have been demolished and others given new uses, most still operate as first intended. Given their urban location, Capitol Hill churches especially cater to the poor, offering food and shelter to the area's needy. As with houses, only a few could be shown here, but Capitol Hill residents have a long history of working to better themselves and their communities.

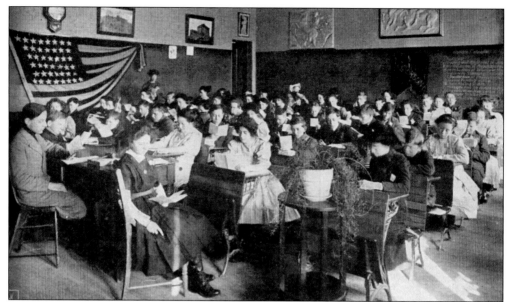

Capitol Hill's oldest school is the 1884 Emerson School at Fourteenth Avenue and Ogden Street, named for Ralph Waldo Emerson and not for Emerson Street. Architect Robert Roeschlaub, who held Colorado's architect license No. 1, designed the school. The building's most distinctive feature is the large sundial on the front of the building. This photograph shows Emerson children in civil government class. No longer used as a school, the building is now a senior center. (*Denver Municipal Facts*, Vol. 3, No. 10, March 4, 1911.)

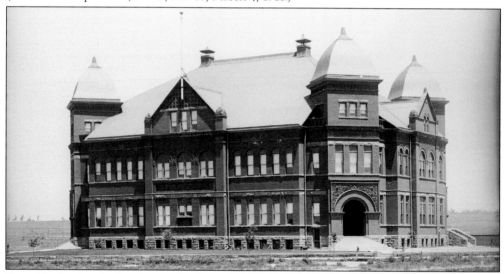

Roeschlaub, the chief architect for Denver Public Schools, also designed the Corona School (1889) at Ninth Avenue and Corona Street, later renamed the Dora Moore School in honor of a favorite principal. According to architectural historian Francine Haber, "Roeschlaub's architectural practice is credited with about fifty school commissions over a forty year period—an incredible number—not counting the many additions he made to these same schools." Yet Roeschlaub was much more than a school architect, designing many famous Colorado buildings like Denver's Trinity Methodist Church, the Central City Opera House, and numerous college buildings, commercial blocks, and residences. (Colorado Historical Society.)

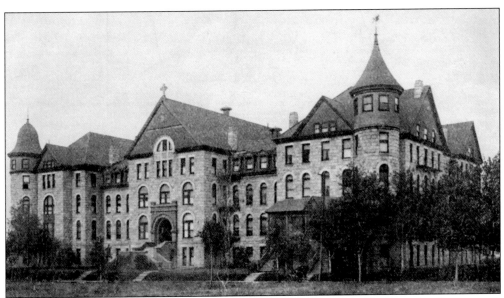

Wolfe Hall, a private girls' school run by the Episcopalians, was originally located at Seventeenth and Champa Streets downtown when it was established in 1867. In 1888, Wolfe Hall relocated to Capitol Hill on land owned by the Episcopal parish St. John's in the Wilderness, between Thirteenth and Fourteenth Avenues and Clarkson and Emerson Streets, where they built this large, turreted stone building. Overseeing Wolfe Hall was headmistress Anna Wolcott. In 1898, Wolcott left to start her own school, the Miss Wolcott School at Fourteenth Avenue and Marion Street. Following her departure, Wolfe Hall struggled financially, closing its doors in 1913. Demolished in 1920, the site is now occupied by Morey Middle School. (*Denver Municipal Facts*, Vol. 2, No. 1, January 1, 1910.)

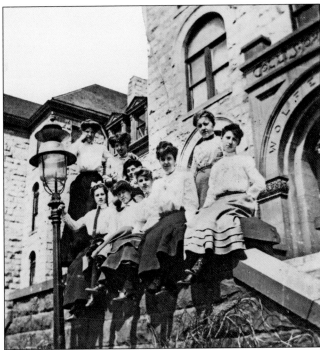

Here Wolfe Hall students pose outside the school in this *c.* 1900 photograph. (Colorado Historical Society.)

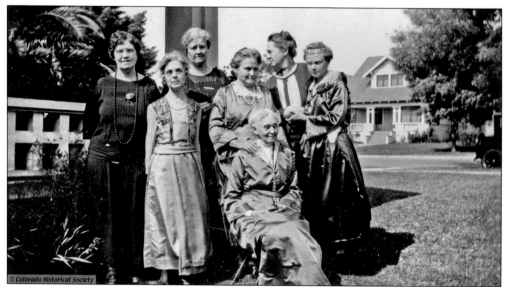

On June 7, 1924, Wolfe Hall alumni gathered for a reunion. Shown here are, from left to right, Julia Large, May Gibbs, Cora McClelland, Mary Johnson, ? Johnson, Cora Wishou, and Clara Johnson. (Colorado Historical Society.)

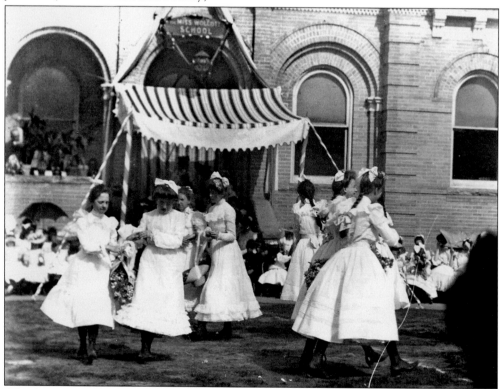

After leaving Wolfe Hall, Anna Wolcott established the Miss Wolcott School, which rose to be the top private girls' school in Denver. When Anna Wolcott retired in 1924, the school closed, and the buildings were converted into apartments, as they remain today. Here Wolcott girls can be seen during their May Day exercises. (Photograph by Harry H. Buckwalter; Tom Noel Collection.)

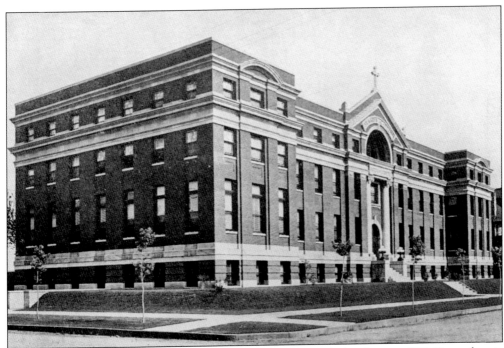

The Catholics also established a private girls' school, St. Mary's Academy, at 1370 Pennsylvania Street. Originally located on the 1400 block of California Street, the academy moved to Capitol Hill to be closer to the Cathedral of the Immaculate Conception. In 1951, the school moved again, this time to Cherry Hills. The building still stands and is used today as offices for the Salvation Army. (*Denver Municipal Facts*, Vol. 4, No. 31, August 3, 1912.)

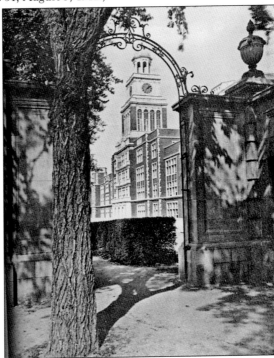

Capitol Hill's public high school is East High School, located just south of City Park. Sixteenth Avenue does not go through at this location, as East takes up the entire two blocks between Colfax and Seventeenth Avenues. Originally located at Nineteenth and Stout Streets in a Robert Roeschlaub–designed building, East moved to Capitol Hill in 1925. Part of the site had been formerly occupied by a racetrack. George Williamson designed the new building reminiscent of Philadelphia's Independence Hall. Large windows allow for natural light. East continues today as one of the top-reputed high schools in Colorado. (*Denver Municipal Facts*, Vol. 9, No. 1/2, January/February 1926.)

Like schools, hospitals needed to be built as Capitol Hill grew. As it happened, several large hospitals were all established in the north part of Capitol Hill. The Catholic St. Joseph's Hospital was the first. The hospital had started out as St. Vincent's, first at Fourteenth and Arapahoe Streets and later at Twenty-sixth and Holladay Streets (now Market Street). The name was changed when construction of a building at Eighteenth Avenue and Humboldt Street began in 1876. The location was far on the outskirts of town before the area became residential. The reason for building hospitals so far on the outskirts of town was twofold: for one, it was believed that patients could recuperate better if they were far from the smoke and grime of the city; but also many residents who were fearful of the spread of sickness believed hospitals should be located far from residential areas. (Tom Noel Collection.)

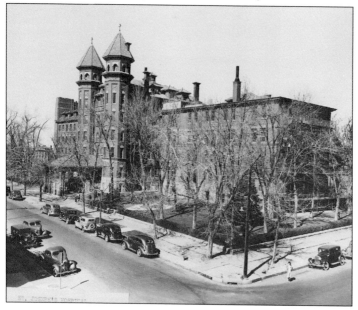

As St. Joseph's grew, the area around it became filled with doctor's offices and medical clinics, and St. Joseph's and the other Capitol Hill hospitals remain the neighborhood's largest employers. Seen here is St. Joseph's, which expanded in 1899 to include a five-story, twin-towered structure. (Tom Noel Collection.)

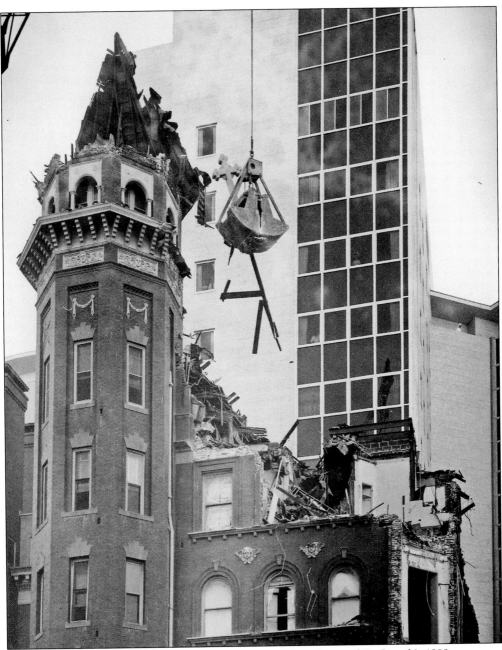

This photograph, taken on June 22, 1964, shows the demolition of St. Joseph's 1899 structure, which had been deemed obsolete and out-of-date. Careful examination of this photograph reveals white-uniformed nurses watching the demolition out the windows of the high-rise hospital building next door. (Tom Noel Collection.)

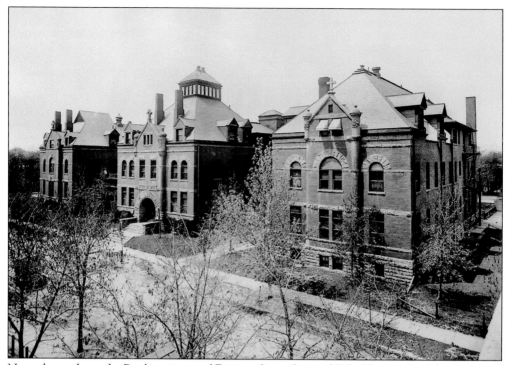

Not to be outdone, the Presbyterians and Episcopalians also established hospitals in North Capitol Hill. The Episcopalians opened St. Luke's Hospital, shown here, at Nineteenth Avenue and Pearl Street in 1891. It had originally been located at West Seventeenth Avenue and Federal Boulevard in an old hotel building. The Presbyterians followed with the Presbyterian Hospital in 1919 at Nineteenth Avenue and Williams Street. In 1979, the two hospitals merged, helping to overcome the financial difficulties that each hospital had experienced separately. Both retained separate facilities before constructing a new complex at Twentieth Avenue and Gilpin Street, whereupon the old St. Luke's site was abandoned. It has since been redeveloped as new condominiums. (Photograph by Louis McClure; Denver Public Library Western History Collection.)

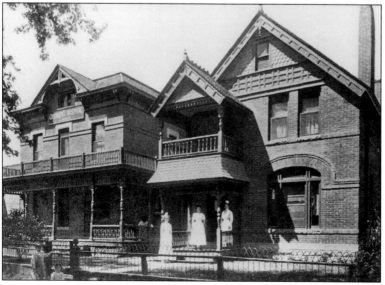

Another North Capitol Hill medical facility, the Children's Hospital, got its start in 1910 in the small home seen at left, located at 2221 Downing Street. (Tom Noel Collection.)

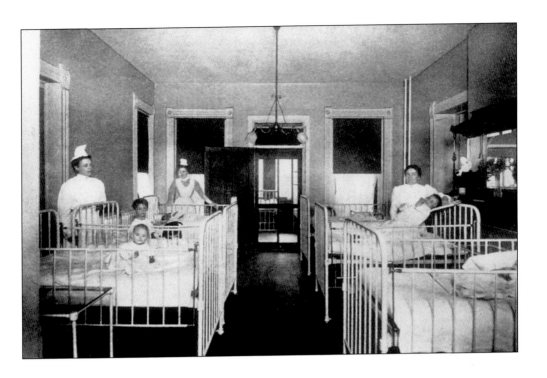

These c. 1910 photographs show the patient area and surgery suite of the original Children's Hospital building. (Both, Tom Noel Collection.)

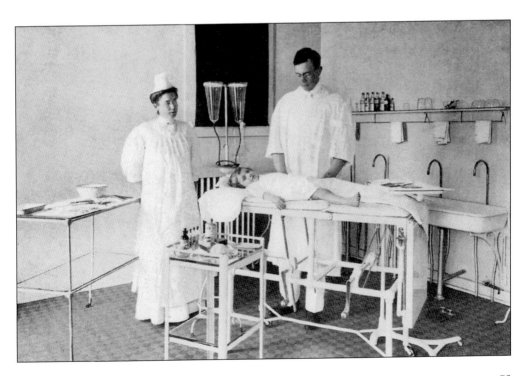

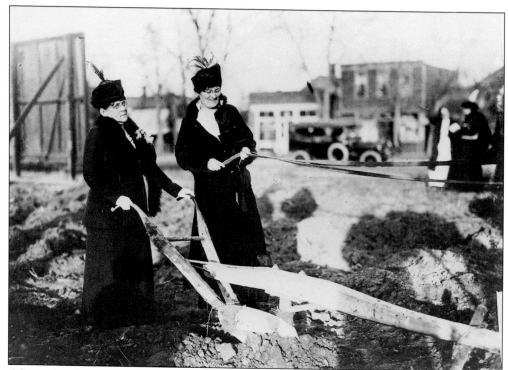

After only a few years, it became clear the old house was too crowded, and Children's Hospital would need to expand. Here Mrs. James C. Burger and Mrs. George B. Packard are shown breaking ground for a new Children's Hospital facility on February 24, 1916. The new hospital would be located just south of the old house, at Twentieth Avenue between Ogden Street and Downing Street. The nurses' quarters, Tammen Hall (1917), still stands as the only remaining original Children's Hospital structure. The Children's Hospital continued to grow as a Capitol Hill institution until 2007, when it was moved to the Fitzsimons campus in Aurora. By 2008, most of the Children's Hospital buildings, aside from Tammen Hall, were demolished. (Tom Noel Collection.)

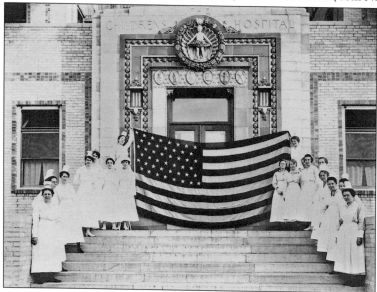

Children's Hospital nurses show their patriotism in this 1918 wartime photograph. (Tom Noel Collection.)

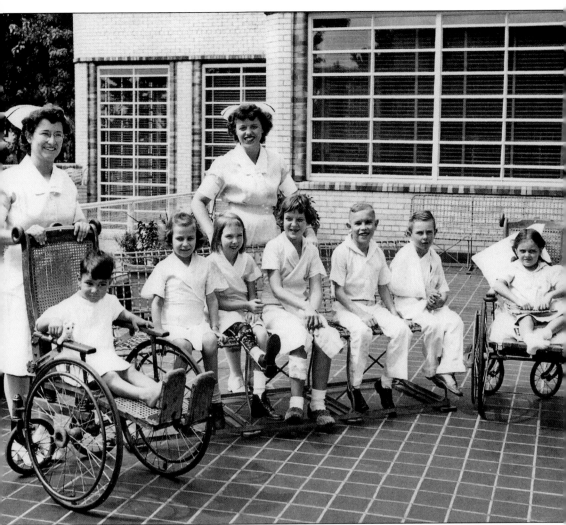

Here young patients at the Children's Hospital accompany their nurses outside. Note the young boy in a wheelchair holding a stuffed animal. Knowing that children are usually scared to go to the hospital, Children's Hospital has always strived to be a fun, child-friendly institution, with toys, games, and even a large dollhouse. (Tom Noel Collection.)

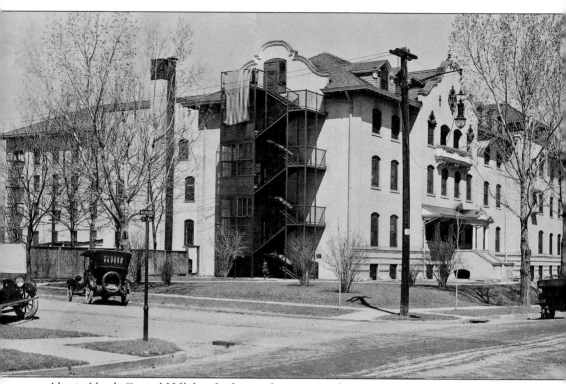

Also in North Capitol Hill, but farther to the east, stood Mercy Hospital. Located at Sixteenth Avenue and Milwaukee Street, Mercy Hospital opened in 1901, founded by the Sisters of Mercy. Like the other Capitol Hill hospitals, it continually expanded. The oldest part of the hospital is shown in this photograph, which includes a rear addition. In 1995, Mercy Hospital's financial situation forced it to close. All of the buildings have been torn down, and a large apartment complex and two luxury high-rise condominium buildings occupy the site. (Tom Noel Collection.)

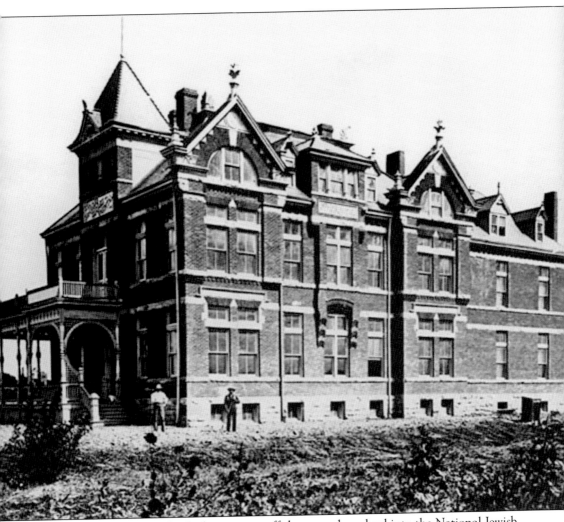

The Frances Jacobs Hospital, which never got off the ground, evolved into the National Jewish Hospital for Consumptives, which opened in 1899 at Colfax Avenue and Jackson Street. National Jewish, with its motto "None may enter who can pay—none may pay who enter" sought to care for Denver's many poverty-stricken tuberculars, particularly new Eastern European Jewish immigrants, who might not always be welcomed with open arms at other consumptive facilities. At the time of its establishment, National Jewish was located far from the polluted air of the city. Over the years, the hospital would continue to expand toward its present location at Colfax Avenue and Colorado Boulevard. Shown here is the earliest building. (Beck Archives, Center for Judaic Studies, University of Denver.)

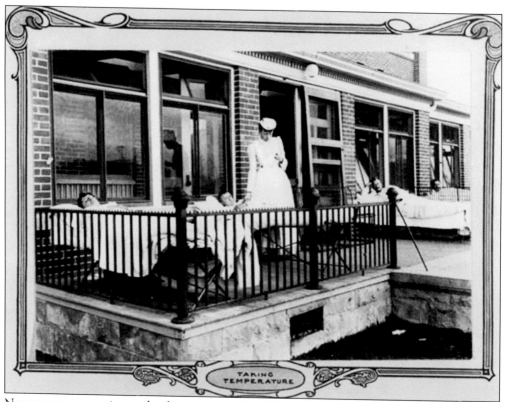

TAKING TEMPERATURE

Numerous consumptives and asthmatics moved to Colorado for the "climate cure" in the late 19th century. Fresh outdoor air was considered to be the most important factor in curing tuberculosis, and as a result, many Capitol Hill houses were built with extra-large porches. Here a National Jewish nurse takes the temperature of an asthma patient on the hospital porch, while younger patients play in the sunshine. (Both, Beck Archives, Center for Judaic Studies, University of Denver.)

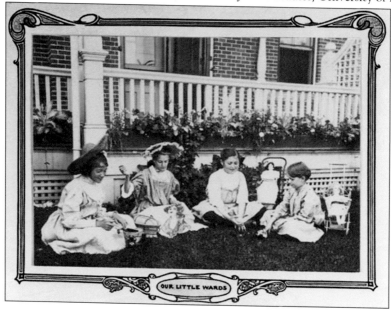

OUR LITTLE WARDS

80

Members of Capitol Hill's Jewish community also built two major synagogues in the neighborhood. The first was Temple Emanuel. Originally meeting downtown, this Reform congregation constructed their new temple, shown here, at Sixteenth Avenue and Pearl Street in 1898. The structure featured two large towers and colorful stained-glass windows. Temple Emanuel thrived until 1957, when the congregation abandoned Capitol Hill for the Hilltop Neighborhood. The building cycled through several subsequent uses, including time as a Southern Baptist church, a United Pentecostal church, and the Temple Events Center. (Author's collection.)

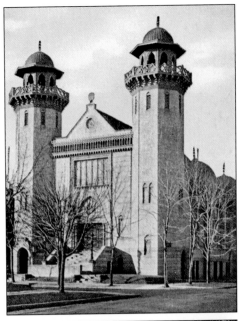

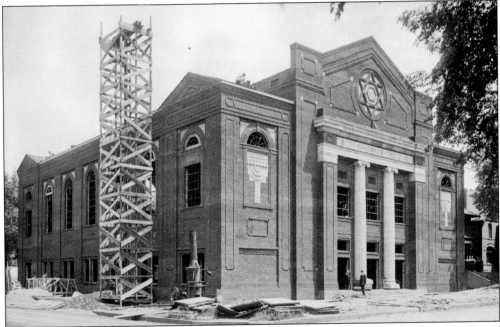

Capitol Hill's other major synagogue was the Beth Ha-Medrosh Hagadol (BMH) at the corner of Sixteenth Avenue and Gaylord Street. This Orthodox congregation, established in 1897, moved to Capitol Hill in 1922. The construction of the synagogue, overseen by architect Samuel Judd (or Judelovitz), a member of a prominent Denver Jewish family, can be seen in this photograph. Eventually, BMH also fled to the suburbs. The old building spent some time as an events center. Jazzercise classes were held in the basement. Mostly, however, the building sat empty. Finally, the Church in the City, which had been using an old Safeway store at Colfax Avenue and Josephine Street, leased the building. After a major restoration, the first services were held there in March 2009. (Denver Public Library Western History Collection.)

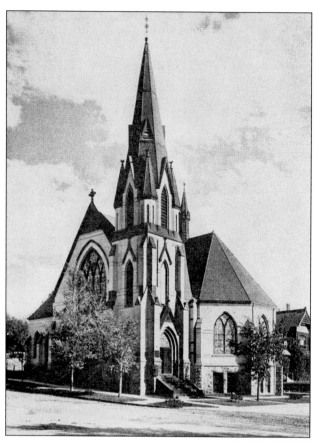

One of Capitol Hill's most elegant churches was this one at Fourteenth Avenue and Lincoln Street, built in 1883. It had originally housed the Capitol Avenue Presbyterian Church (as Fourteenth Avenue had once been named Capitol Avenue). When that church vacated in 1895, First United Presbyterian bought the structure. Remaining until 1963, the building was razed the following year. The First United congregation exists today as the Green Mountain United Presbyterian Church in Lakewood. The Fourteenth and Lincoln site is currently occupied by a state parking facility. (*Denver Municipal Facts*, Vol. 4, No. 10, March 9, 1912.)

Another Presbyterian church, Central Presbyterian, established in 1860, still thrives on Capitol Hill. This sandstone, Romanesque Revival–style structure was constructed in 1892 and was designed by architects Frank Edbrooke and Willis Marean. Visible at the far right in this photograph is the three-story, turreted manse, or parsonage, which the church razed in 1956 to make way for a modern Parish House. (*Denver Municipal Facts*, Vol. 4, No. 11, March 16, 1912.)

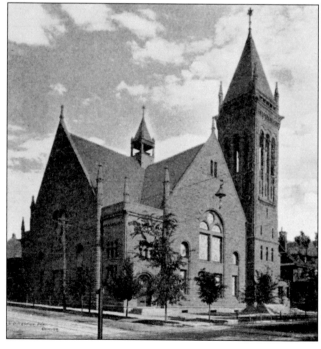

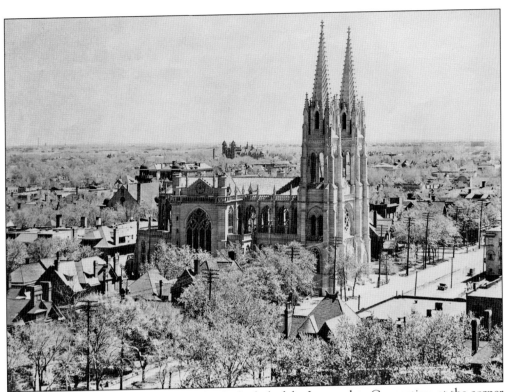

Denver's Roman Catholics dedicated the Cathedral of the Immaculate Conception, at the corner of Colfax Avenue and Logan Street, on October 27, 1912. The French Gothic structure cost $500,000 to build, complete with altars of Carrara marble. The twin spires reach 210 feet into the air, occasionally attracting lightning strikes. The exterior is of gray Indiana limestone. The cathedral nears completion in this photograph, though the 36 German stained-glass windows had not yet been installed. (Photograph by Louis McClure; Denver Public Library Western History Collection.)

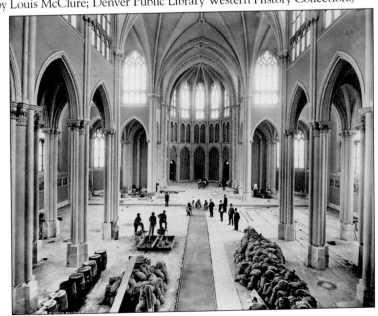

Here workers put the finishing touches on construction of the Immaculate Conception cathedral nave. (Tom Noel Collection.)

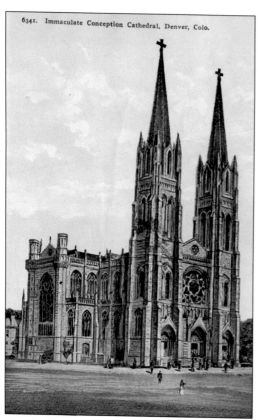

In 1979, the Vatican elevated Denver's cathedral to a basilica. Cathedrals can only be called basilicas if the Vatican determines that they are extremely important in terms of history, architecture, and community service. In 1993, Pope John Paul II said Mass at the basilica during his travels to Denver for World Youth Day. (Author's collection.)

St. John's in the Wilderness is the Episcopalians' answer to the Cathedral of the Immaculate Conception. Before moving to Capitol Hill, this church had been located on the triangular lot between Broadway, Welton Street, and Twentieth Street. When arsonists destroyed the church in the middle of the night on May 15, 1903, the congregation decided to rebuild on Capitol Hill at Fourteenth Avenue and Clarkson Street on land the church had owned since the 1860s. Shown here is original plan for the Capitol Hill church. Budget constraints forced St. John's to eliminate the central tower. (Colorado Historical Society.)

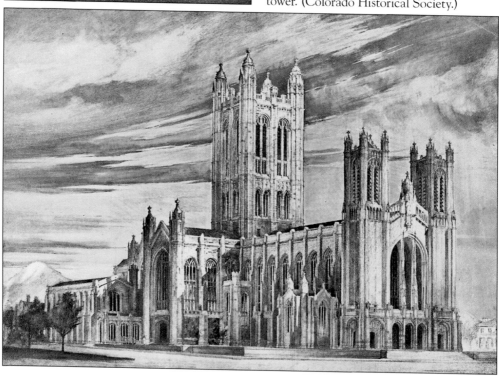

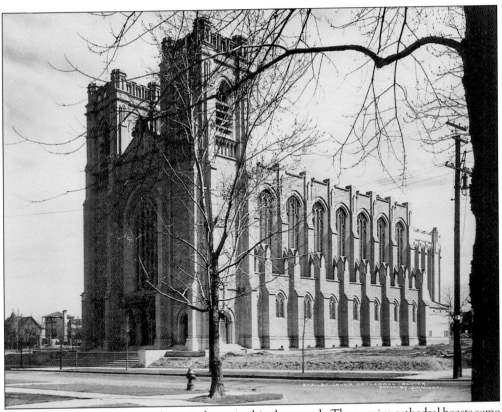

St. John's at the time of its completion is shown in this photograph. The massive cathedral boasts some of Denver's finest stained-glass windows. (Photograph by Louis McClure; Tom Noel Collection.)

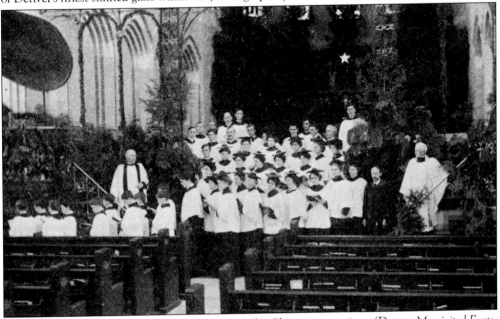

Shown here is the choir of St. John's, preparing for Christmas services. (*Denver Municipal Facts*, Vol. 4, No. 13, March 13, 1912.)

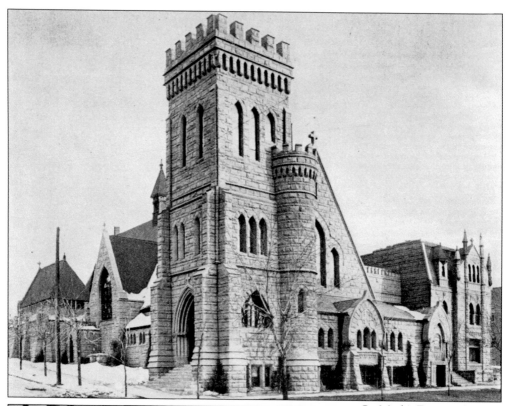

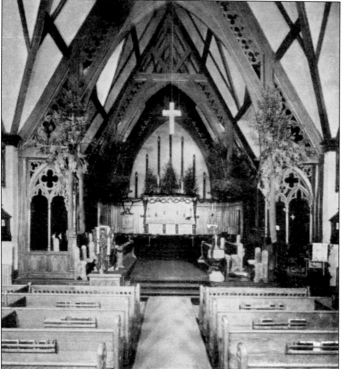

St. Mark's Episcopal Church still stands at the corner of Twelfth Avenue and Lincoln Street, though it has ceased its use as a church. Instead the building is now a popular nightclub. The massive tower seen in the above photograph is gone, having collapsed onto the street below. (*Denver Municipal Facts*, Vol. 3, No. 1, December 31, 1910.)

St. Mark's interior, seen at left, featured decorative wood trim. Architect William Lang designed the structure in 1890. (*Denver Municipal Facts*, Vol. 3, No. 1, December 31, 1910.)

First Divine Science Church, at Fourteenth Avenue and Williams Street, played an important role in the founding of this denomination. Nona Lovell Brooks, Denver's first female minister, established the congregation. Suffering ill health as a young woman, Brooks began studying metaphysics and claimed to be cured. Intrigued, she partnered with Malinda Cramer, who had founded Divine Science in San Francisco. Brooks offered her spiritual guidance while Fannie Moffat offered her financial support in establishing a new church in Denver, meeting in a small building at Seventeenth Avenue and Clarkson Street. After the San Francisco earthquake of 1906, Denver became the world headquarters of Divine Science, and Nona Brooks worked to spread her religion around the world. (*Representative Women of Colorado*, 1914.)

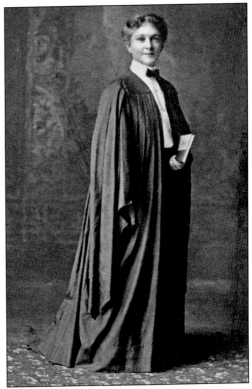

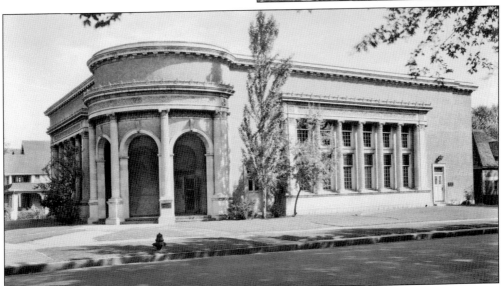

In the 1920s, the Divine Scientists hired architect Jacques Benedict to build this neoclassical edifice. Benedict (1879–1948), one of Denver's most significant architects of the 1920s and 1930s, is responsible for numerous Capitol Hill buildings, including many Beaux Arts and Mediterranean-style residences in the Cheesman Park area. Some of Benedict's most famous designs were never actually built, however, including a "Summer White House" atop Mount Falcon and a rejected plan for the City and County Building—which he envisioned as a skyscraper. (Denver Public Library Western History Collection.)

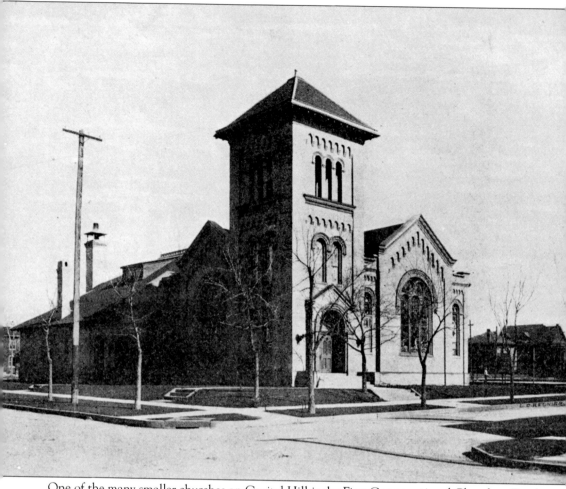

One of the many smaller churches on Capitol Hill is the First Congregational Church at Tenth Avenue and Clarkson Street. Designed by Robert Roeschlaub in 1907, it is the architect's final church design, completed with the assistance of his son Frank. Inside and outside, the church is a combination of many architectural styles, including elements invoking everything from medieval, to Georgian, to Arts and Crafts. The building later became the Metropolitan Community Church of the Rockies, and the pyramidal roof atop the tower has disappeared. (*Denver Municipal Facts*, Vol. 4, No. 24, June 15, 1912.)

Four

COLFAX

East Colfax Avenue is the heart of Capitol Hill. Today the neighborhood's main commercial drag, East Colfax actually started out as an exclusive residential avenue. It was named for Schuyler Colfax, an Indiana congressman who served as Speaker of the House and later as vice president under Ulysses S. Grant. When Colfax visited Denver in 1865, the town named their avenue Colfax to flatter the politician into supporting Colorado's bid for statehood.

Colfax Avenue bisects the Capitol Hill neighborhood but runs far beyond the Hill's borders on either side. East Colfax starts at Broadway and continues into Aurora, while West Colfax, the portion west of Broadway, stretches out to Golden. Colfax is said to be America's longest street; the *New York Times* has also called it America's wickedest. From its early days as a mansion district, East Colfax evolved into a busy street lined with stores, apartments, and bars. By the 1960s, some internationally known performers like Bob Dylan, Judy Collins, and the Smothers Brothers got their start performing in Colfax Avenue joints like the Satire Lounge. Less reputable establishments, such as adult book and video stores and strip joints, like Sid King's famous Crazy Horse Bar, started opening up on the avenue. Soon East Colfax would also gain a reputation for prostitution. Motels were used more by the hour than by the night. Fights, drug dealing, and other seedy activity became commonplace. East Colfax's No. 15 bus became the most notorious bus route in town.

In recent years, the City of Denver has worked to clean up Colfax Avenue. New luxury high-rises and a resurgence of interest in fixing up old homes has changed the avenue, as has a new main street zoning ordinance, which calls for area beautification through such improvements as street trees, and parking lots are not allowed in front of any new buildings. Some city council members are even working to bring back a trolley system along Colfax. Such improvements have cleaned up the area, but it still retains its own Colfax character. Wild and wicked happenings are still common. But most nearby residents knew this when they bought their homes. Living near Colfax is not like living anywhere else. And for urbanites who would not dream of living in suburbia, Colfax offers an experience unlike anywhere else in Denver.

Early Capitol Hill transportation included the horsecar, pictured above. The service was overseen by the Denver City Railway Company, which began laying track in the 1870s. In this photograph, a horse pulls the No. 125 west on Colfax Avenue from York Street toward Broadway. For the return trip, the second horse, seen here with a rider, would be hitched up to help the car uphill. Other places used more ingenious tactics, such as Englewood's Cherrelyn horsecar. On that line, the horse would pull the car uphill, then climb on board for a ride back downhill. (Colorado Historical Society.)

The sparseness of early Capitol Hill is well evidenced in this 1890s photograph looking westward from Colfax Avenue and Lafayette Street. (*History of Denver*, Jerome Smiley, 1901.)

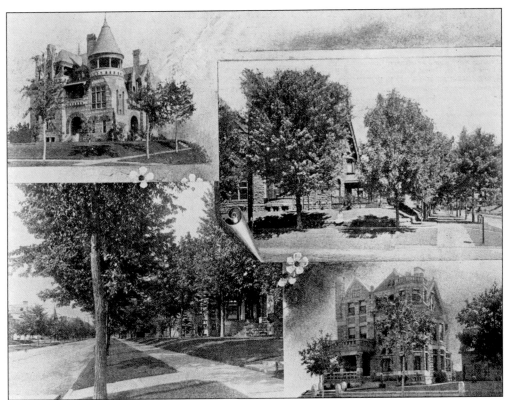

Almost unbelievable today is the fact that Colfax actually started out as an avenue of fine mansions. A few of these houses still remain, but they are hard to find—tacked-on commercial storefronts have all but obscured them. *Denver Municipal Facts*, as a promotional magazine, liked to show off Denver's mansions. In 1909, the magazine prepared this collage of attractive Colfax Avenue dwellings at a time when an address on Colfax was a sign of distinction. The house in the bottom right corner is the Raymond House (Castle Marne). In the upper left is the Gustofson-McGill Mansion, which sat prominently on the southeast corner of Colfax Avenue and Gilpin Street. By the 1930s, this grand home gained a reputation as the neighborhood haunted house. The home was demolished in 1933 for an automobile showroom. (*Denver Municipal Facts*, Vol. 1, No. 17, June 12, 1909.)

Another lovely Colfax mansion was the McKay House at 2839 East Colfax Avenue, between Detroit and Fillmore Streets. John H. McKay, a physician from Mississippi, lived here with his wife, Beulah, and daughter, Gertrude. (*Denver Municipal Facts*, Vol. 2, No. 32, August 6, 1910.)

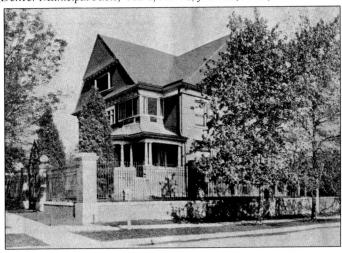

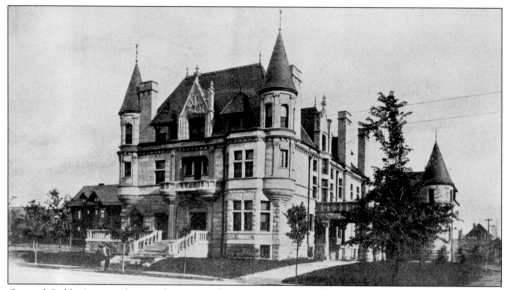

One of Colfax's most famous homes is the Bethel-Phipps Mansion at the southwest corner of Colfax Avenue and Marion Street. This French chateau first belonged to Capt. William D. Bethel, a transplant from Tennessee who had fought for the Confederacy. About 1911, Lawrence Cowles Phipps purchased the castle. Phipps had grown wealthy as a vice president of Carnegie Steel and later served in the U.S. Senate from 1918 to 1930. Phipps and his wife, Margaret, whose father, Platt Rogers, had served as mayor of Denver, later built a Georgian mansion in 1933 in southeast Denver, which they named Belcaro. (*Denver Municipal Facts*, Vol. 1, No. 17, June 12, 1909.)

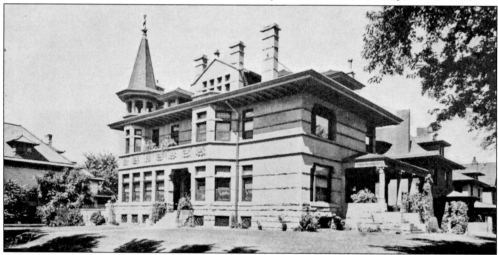

This unusual home at the corner of Colfax Avenue and Vine Street looks like a Denver Square from the front—but as this photograph reveals, the back of the home features a turret and other elements completely uncharacteristic of a Foursquare. It combines the ornamentation of the late 19th century with the simplicity of the early 20th. Built for R. M. Quigley, the home was replaced by the art deco Leetonia apartment building. The still-extant Leetonia was once owned by Frank Ricketson, who also owned a chain of movie theaters and was the originator of the "bank night" movie specials during the Great Depression. The Ricketson Theatre at the Denver Center for the Performing Arts is named for him. (*Denver Municipal Facts*, Vol. 3, No. 40, September 30, 1911.)

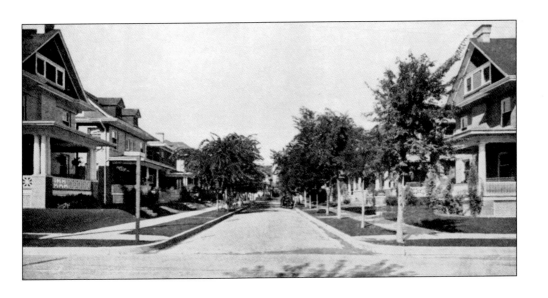

Tucked in between Colfax and Fourteenth Avenues between Cook and Madison Streets is a hidden gem, the Snell Addition Historic District. This tiny district consists of Colfax A and Colfax B Places, shown in these photographs, respectively. The district is named for Frank Snell, who built 25 houses here between 1905 and 1911. Snell's idea was to fit more houses in the block by eliminating the backyards. The developer himself lived in a home at 3421 Colfax A. Across the street at 3422 Colfax A lived Louisa Ward Arps, author of the classic local history *Denver in Slices* (1959). Today Colfax A and Colfax B Places remain virtually unchanged, a step into early-20th-century Denver. (Both, *Denver Municipal Facts*, Vol. 3, No. 38, September 16, 1911.)

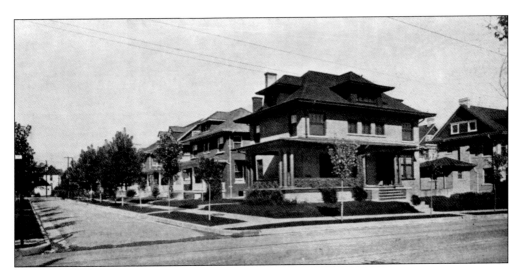

One of Denver's biggest blizzards occurred on December 4, 1913, dumping 25.8 inches of snow on the city in 24 hours. Much of the snow was hauled to the Civic Center, where piles lasted well into the summer of 1914. This photograph illustrates the gridlock resulting from the piled-up snow. Seen here is the corner of Colfax Avenue and Sherman Street, just across from the state capitol. Note the young man carrying skis. (Photograph by George L. Beam; Denver Public Library Western History Collection.)

Another view of the 1913 storm shows waist-deep snow and backed up streetcars at Colfax Avenue and Downing Street. Visible at right is the Bethel-Phipps Mansion. (Tom Noel Collection.)

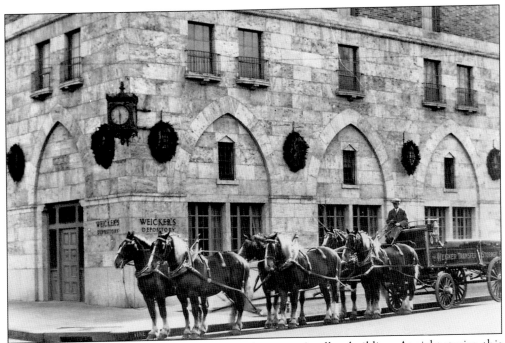

One of Colfax's early commercial structures is the avenue's tallest building. At eight stories, this building at Colfax Avenue and Vine Street resembles a medieval fortress with its tiny windows and crenellated roofline. Weicker Moving and Storage hired architects Fisher and Fisher to design this building around 1925. Still used as a storage facility today, it surely must be one of the few existing storage facilities with travertine marble walls. (Tom Noel Collection.)

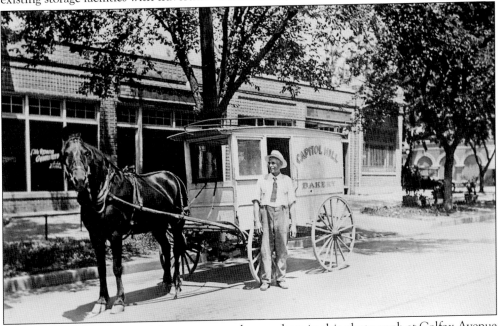

More early Colfax commercial structures can be seen here in this photograph at Colfax Avenue and York Street. Businesses include the Colfax Auto Company, Andrew Lang Drug Store, and August Jensen with his Capitol Hill Bakery wagon. (Tom Noel Collection.)

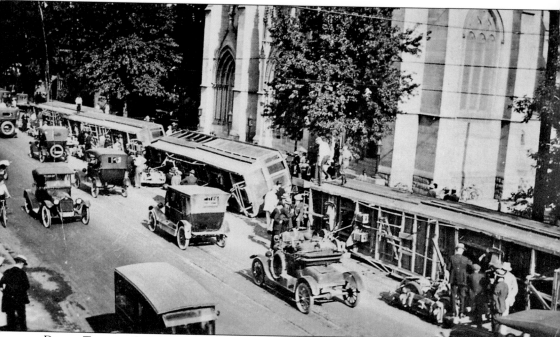

Denver Tramway Company workers overturned tram cars during a 1920 strike, shown here in front of the Cathedral of the Immaculate Conception at Colfax Avenue and Logan Street. On Colorado Day, August 1, 1920, Denver Tramway workers went on strike for better pay. On August 5, rioters overturned five tram cars on Colfax, then went on to cause other damage and vandalism around the city. The National Guard had to be called in to restore order. (Tom Noel Collection.)

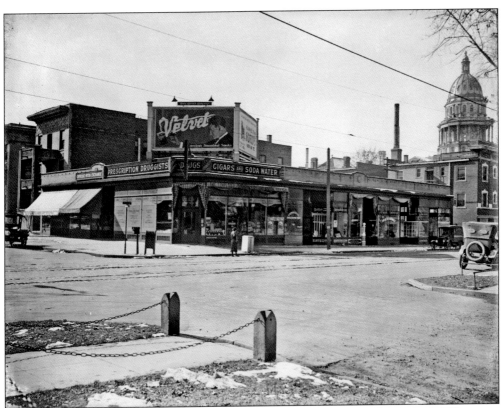

Across the street from the Cathedral of the Immaculate Conception was the Cathedral Pharmacy at the southwest corner of Colfax Avenue and Logan Street, owned by Christian Van Zandt. The location has housed several restaurants over the years. Visible to the right is the Hotel Newhouse. This building housed soldiers during World War II, who had fun throwing water balloons out the windows onto pedestrians below. (Photograph by Louis McClure; Denver Public Library Western History Collection.)

Another Colfax apartment building is the Pencol Apartment Building. The name is a combination of Pennsylvania and Colfax, the streets on which the building sits. Still standing today, it was built by architect Walter Simon in 1925. (Photograph by Louis McClure; Denver Public Library Western History Collection.)

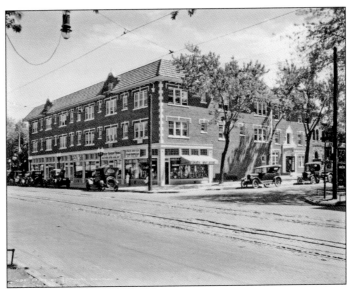

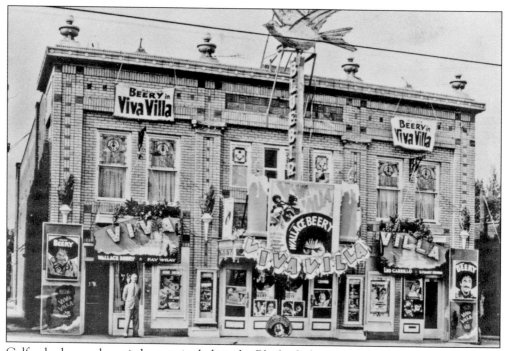

Colfax had several movie houses, including the Bluebird, shown here in 1933, and the Aladdin at Colfax Avenue and Race Street, which made history as the first theater west of the Mississippi to show a talkie. Eventually, however, the Colfax movie palaces declined with the neighborhood. The Aladdin was torn down. Finally, Bluebird was restored and designated a Denver Landmark in 1994. It has been recycled as a live-concert venue, along with two other Colfax theaters, the Ogden and the Fillmore, which had originally been the Mammoth Gardens skating rink and later a Frichtle automobile dealership. (Denver Public Library Western History Collection.)

Helen Bonfils purchased land on the south side of Colfax between Columbine and Elizabeth Streets to build this 550-seat theater, completed in 1953. After her death, Donald Seawell established the Denver Center for the Performing Arts (DCPA), naming the complex's main theater the Bonfils. To avoid having two Bonfils Theatres in Denver, the Colfax venue changed its name to the Lowenstein Theatre after Henry Lowenstein, who had overseen performances there. Never really successful after the opening of the DCPA, the theater was transformed into the Tattered Cover Book Store and a restaurant in 2006. (Tom Noel Collection.)

Five

PARKS

Capitol Hill's parks have long been a very special part of life in the area. City Park, Denver's largest, extends nearly 400 acres at the northern edge of Capitol Hill, stretching along Seventeenth Avenue all the way from York Street to Colorado Boulevard. City Park has always been promoted as a place of both relaxation and recreation, as well as what historian Phil Goodstein calls "an outdoor art gallery." Throughout the park are myriad statues, memorials, and fountains. The elaborate stone Sullivan, Sopris, McClellan, and Monti Gateways allow for a grand entrance to the park, while the City Park Pavilion is a scenic gathering place.

Capitol Hill's other major park is Cheesman Park, which actually started out as the Mount Prospect Cemetery in 1859. After notorious gambler Jack O'Neal, a victim of murder, was buried in Mount Prospect, some started calling it O'Neal's Ranch. Eventually, it came under the possession of the city and was rechristened the City Cemetery. The cemetery was planned as a green, park-like setting. Lack of water, however, made this difficult. By the time the City Ditch brought water to Capitol Hill, the neighborhood was expanding, with residential development creeping ever closer to the graveyard. As residents wanted to move closer to the area, the city decided the cemetery needed to be moved and a park built instead.

Today's Cheesman Park is ringed by condominium high-rises. Volleyball and sunbathers are common sites in the park—as are rectangular-shaped depressions in the ground where the grass is just a little greener than that surrounding it. Approximately 2,000 graves still remain in the Cheesman Park area, and occasionally workers excavating around the park or in the adjacent Denver Botanic Gardens have to stop work when they stumble upon a corpse.

In addition to City Park and Cheesman Park, other smaller parks have been established, such as Governor's Park near the Colorado Governor's Mansion, and Quality Hill Park, a small area at the southeast corner of Tenth Avenue and Pennsylvania Street. With the many apartment and condominium buildings in the neighborhood, parks provide the important function of serving as a backyard to many Capitol Hill residents.

This cemetery certificate is signed by the man who founded both the cemetery and the city—William Larimer. (Tom Noel Collection.)

Seen here is the Catholic section, Mount Calvary. In this photograph, a flower wagon enters the cemetery for Decoration Day (now known as Memorial Day). (Tom Noel Collection.)

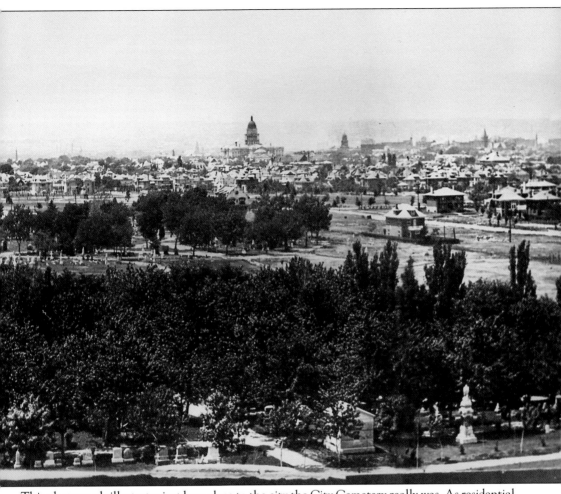

This photograph illustrates just how close to the city the City Cemetery really was. As residential construction crept closer and closer to the graveyard, plans were made to move the bodies. (Tom Noel Collection.)

In 1893, undertaker Edward P. McGovern got the job of digging up and moving any bodies not claimed by relatives. Receiving $1.90 per coffin moved, McGovern instructed his workers to fill each small pine box with just a few bones, often splitting a single corpse into multiple coffins; others he filled simply with rocks and branches. Shocked Denverites called for McGovern's dismissal. Yet despite the scandal, McGovern would continue to run a successful mortuary near Colfax Avenue and Washington Street. The Catholic cemetery, Mount Calvary, though no longer burying anyone after 1908, would remain mostly intact for the next several decades. In 1937, some Mount Calvary corpses were removed to build an underground drainage system, as shown in these photographs. The remaining bodies were cleared in the 1950s for the Denver Botanic Gardens. No doubt, soil rich with bone meal fertilizers has contributed to this being an ideal location for the gardens. (Both, Tom Noel Collection.)

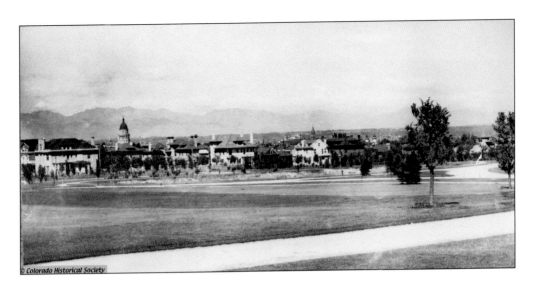

These early photographs of Cheesman Park offer a panorama of old Denver. In the above photograph, landmarks such as the state capitol, Central Presbyterian Church, and Temple Emanuel can be seen, while the Corona (Dora Moore) School dominates the photograph below. (Both, Colorado Historical Society.)

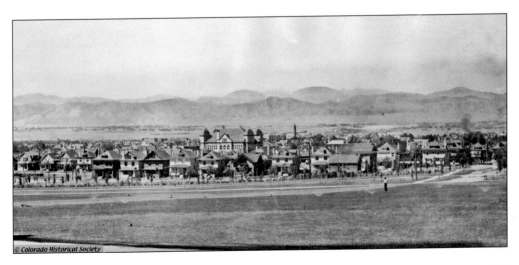

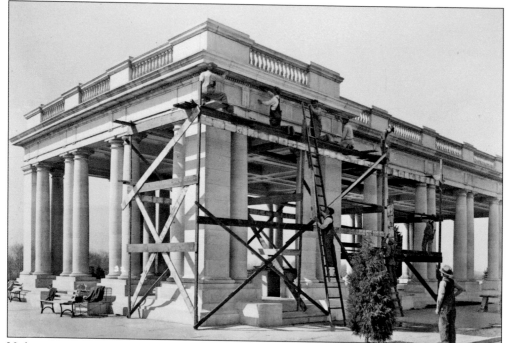

Utility magnate Walter S. Cheesman's widow, Alice, and daughter, Gladys, gave the money for the Cheesman Memorial, which was designed by Willis Marean and Albert Norton in 1908. Alice Cheesman hired the same architects to build her mansion at Eighth Avenue and Logan Street. Completed in 1910, the Cheesman Memorial Pavilion is constructed of white Colorado Yule marble. Before the Cheesmans' donation, the park had been named Congress Park. The park today known as Congress Park, east of Cheesman, is named to commemorate the early name of Cheesman Park. (Tom Noel Collection.)

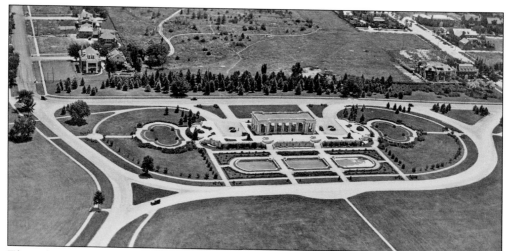

The Cheesman Memorial Pavilion and its surroundings are shown in this 1912 aerial photograph. At that time, many vacant lots still dotted the surrounding neighborhood. (Jackson Thode Collection.)

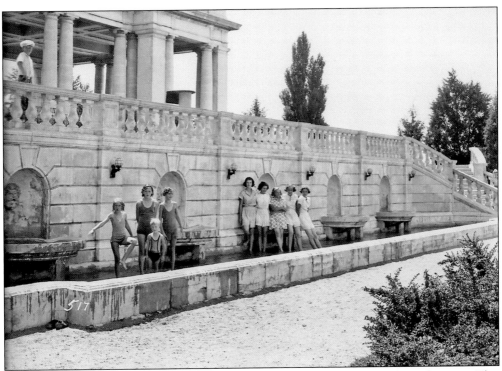

Children were able to cool off on hot summer days by splashing in the Pavilion's fountain. This photograph dates from 1934. (Colorado State Archives.)

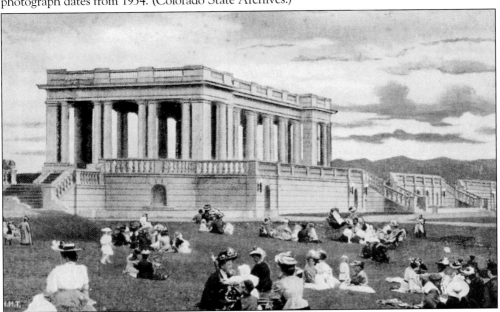

Concerts were a common use of the Cheesman Memorial Pavilion. Each summer from 1934 to 1972, the *Denver Post* hosted Broadway musicals and operatic performances at the pavilion. Although the *Denver Post* opera productions were never a hit with the critics, they brought satisfaction to Helen Bonfils, who had worked hard all her life to bring the fine arts to Denver. (Tom Noel Collection.)

Nearby properties grew in value as a result of their being adjacent to a park. Seen in this 1911 photograph are some of the fine homes just outside Cheesman Park. (*Denver Municipal Facts*, Vol. 3, No. 3, January 14, 1911.)

A rustic-style gazebo helped park visitors feel as though they were escaping the busy, grimy city. The gazebo still stands and has recently been restored. (*Denver Municipal Facts*, Vol. 2, No. 40, October 1, 1910.)

This World War I–era Curtiss Jenny biplane drew a large crowd when it was exhibited in Cheesman Park in 1916. (Roy Klein.)

The same airplane is shown here after it crashed. These photographs are from the family album of Ralph Boyer (1912–2003), who grew up in Denver and had a long career teaching French in the Denver Public Schools. (Roy Klein.)

Denver's City Park had once housed a small botanical garden, but it never really "grew." Its proximity to a recreational park led to more plucking and trampling than anything else. So in the 1950s, the city developed a new Denver Botanic Gardens on the old Calvary Cemetery site. The large house seen in this photograph, taken shortly after the opening of the park, is the Campbell-Waring Mansion at Ninth Avenue and York Street. This Jacques Benedict–designed mansion was constructed in 1926 for Richard and Margaret Campbell, who had previously lived in the Croke-Patterson-Campbell Mansion. They would only enjoy it for a few years, as Margaret died in 1929 and her husband followed her in death a year later. Later owners Dr. James and Ruth Waring donated the house to the Denver Botanic Gardens, which uses the facility as a library and meeting spaces. (Author's collection.)

A grant from the Boettcher Foundation in 1963 enabled the construction of the Boettcher Conservatory. Charles Boettcher, the family patriarch, had made his fortune through industries such as Great Western Sugar and Ideal Cement. To commemorate Boettcher's cement empire, the conservatory was constructed of the material, as were cement lampposts meant to resemble trees. The conservatory houses tropical plants that need a special warm climate to survive. Therefore, even in the dead of winter, the conservatory offers a burst of greenery. (Tom Noel Collection.)

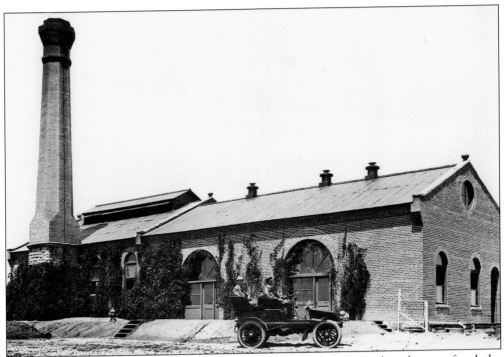

After the original Congress Park was renamed Cheesman Park, a new park to the east of took the Congress Park name. The new park, situated at Eighth Avenue and Josephine Street, includes part of the original City Cemetery's Hebrew section. Congress Park would play a major role in Capitol Hill's water system. In the 1880s, the area near present-day Congress Park was designated for the neighborhood's water storage. Parts of the old Hebrew Cemetery were cleared to build a reservoir between Columbine and Elizabeth Streets south of Eleventh Avenue. Increased demand led to the construction of two additional reservoirs by the 1950s. Shown here is the water department's coal-fired pump station, now demolished. (Denver Water.)

At the northern edge of Capitol Hill is City Park. This c. 1890 photograph shows the Denver Municipal Band performing in the old City Park bandstand. The band's most famous conductor, Rafaello Cavallo, also conducted the orchestras of the Tabor Grand Opera House and Elitch's. His wife, Margaret, taught acting at the Tabor Grand, and his stepdaughter, Maude Fealy, became a Hollywood actress during the silent film era. (Denver Public Library Western History Collection.)

The many trees shown in this photograph are reflective of the City Beautiful movement's emphasis on tree planting. During this era, the City of Denver would provide free trees to city residents on Arbor Day. (*Denver Municipal Facts*, Vol. 3, No. 7, February 11, 1911.)

In this photograph, a couple can be seen canoeing on City Park Lake. The lake also boasted the colorful Electric Fountain and a bigger boat named the *Miss Denver*. The boat would eventually be moved to Lakeside Amusement Park, where it sunk. (Photograph by Louis McClure; Tom Noel Collection.)

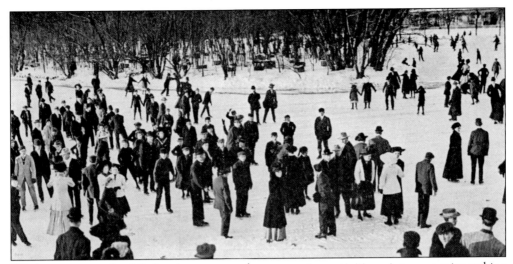

While canoeing and paddle-boating were popular summertime activities, winter meant ice-staking on the frozen City Park Lake. (*Denver Municipal Facts*, Vol. 3, No. 1, December 31, 1910.)

Architect Jacques Benedict drew up these plans in 1910 for an esplanade that would extend from the Museum of Natural History to the lake. Benedict modeled his design after a park in Paris. (Archives, University of Colorado at Boulder.)

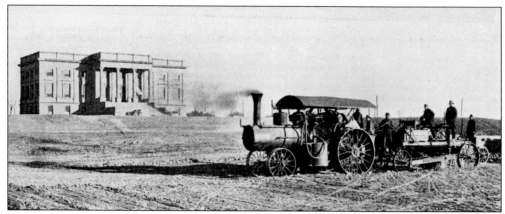

The Denver Museum of Natural History (today the Denver Museum of Nature and Science) at Twentieth Avenue and Colorado Boulevard is one of the city's most popular attractions. Seen here is the original museum building, before many additions, with workers grading for Benedict's esplanade. (*Denver Municipal Facts*, Vol. 3, No. 7, February 11, 1911.)

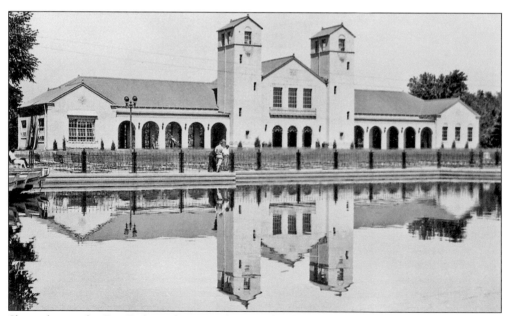

Shown here is the City Park pavilion in a photograph taken about 1918. (Tom Noel Collection.)

Six

COMMUNITY AND LIFE

With its rich diversity of people and places, Capitol Hill offers something for everyone. In addition to houses and institutions, Capitol Hill has a large commercial presence, not just on Colfax Avenue but also along Sixth Avenue and the numbered avenues north of Eleventh. Over the years, Capitol Hill has been home to many fraternal organizations that have enlivened the city. Theaters, art galleries, and some of Denver's finest restaurants bring culture to the area.

Since its founding, Capitol Hill has always been home to a wide variety of people. Even in its earliest years, the city's demimonde were not the only ones to make Capitol Hill their home. As the neighborhood grew, so did the types of housing, and the types of people. A number of nationally known celebrities, past and present, have had associations with Capitol Hill, while the greats who fashioned Denver often had Capitol Hill addresses. Yet many ordinary people lived in the area, too. It has continued to be a patchwork quilt of people and places, sights and sounds, history and culture. Some parts are wicked, some parts are wealthy. Yet everywhere on Capitol Hill, there is a story to be told.

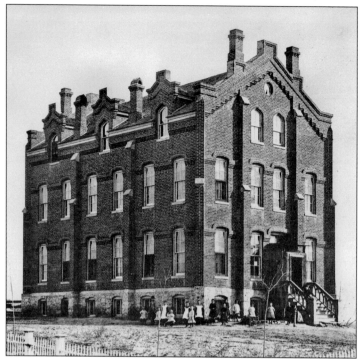

One of the earliest buildings on Capitol Hill was the Ladies' Relief Society at 800 Logan Street in 1876. Originally a children's home, it later became a ladies' shelter. When the area around Eighth Avenue and Logan Street became prime real estate a few years later, John Campion, who owned a large mansion across the street, bought the property, and the society moved out, relocating to West Thirty-eighth Avenue and Quitman Street in North Denver. The home was demolished by 1903. (Tom Noel Collection.)

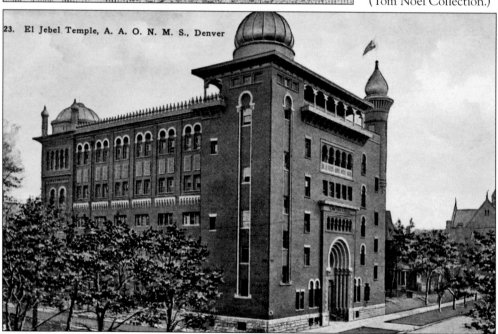

23. El Jebel Temple, A. A. O. N. M. S., Denver

El Jebel Temple is the city's best example of Moorish architecture. At the southeast corner of Eighteenth Avenue and Sherman Street, the Masons built this structure, completed in 1907, as headquarters of their branch known as the El Jebel Shrine. Though the Shriners moved out in 1924, the building went to another branch of the Masons, the Rocky Mountain Consistory No. 2, which used the building until 1992. Recently the building has been used as an events center. (Author's collection.)

Another group, the University Club, meets at the southwest corner of Seventeenth Avenue and Sherman Street. The club constructed this building in 1895, complete with a bowling alley and theater. The large apartment building south of the club in this photograph was owned by engineer-architect Samuel Judd, builder of the BMH Synagogue. Judd's grandchildren remember watching Fourth of July fireworks from the balcony at the back of the building. The site is now a parking lot for an adjacent office tower. (*Denver Municipal Facts*, Vol. 3, No. 3, January 14, 1911.)

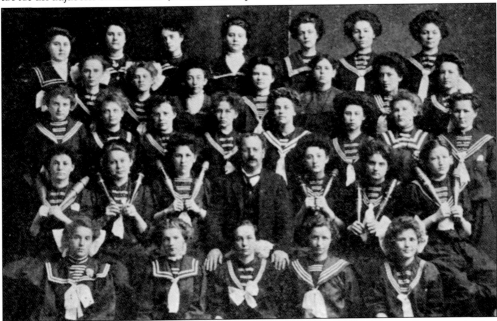

The Denver Turnverein, a club for those of German descent, stressed exercise and gymnastics but also met to discuss German politics and culture. During World War I, Germans were targeted, and many club members resigned. The group recovered, however, and soon moved to a new home at Sixteenth Avenue and Clarkson Street in the former Coronado Club, an upscale dance hall. Today the Turners still use the structure, offering dance classes open to all. This 1911 photograph shows the Turnverein's girls' gymnastics team. (*Denver Municipal Facts*, Vol. 3, No. 28, July 8, 1911.)

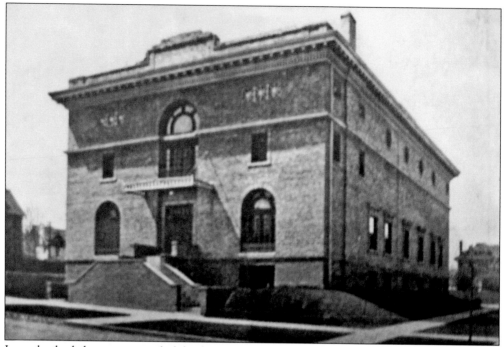

Jews also had their own social club, the Jewish Progress Club, whose 1912 clubhouse stood at Colfax Avenue and Williams Street. In 1928, the Progress Club sold the building to another Jewish organization, the B'nai B'rith, who renamed it the B'nai B'rith–I. Rude Community Building. In 1949, it became the Jewish Community Center, or JCC. The building was replaced by a gas station in the 1960s. (*Denver Municipal Facts*, Vol. 2, No. 15, May 9, 1914.)

At the time of this photograph, the Capitol Hill Police Station was at Colfax Avenue and York Street. The policemen in this 1913 squad photograph are, from left to right, (last names only) patrolmen Cook, Hokans, and Duncan; sergeants Russell and Parslow; and patrolmen Burdett, Kerin, Blue, Scott, Bates, Wolf, Gallagher, McMahill, Stills, Secrest, Smith, Lynton, Hendricks, Sellers, Callahan, Clinch, Lahey, Foster, Mallory, Gardner, and Sharpe. (*Denver Municipal Facts*, Vol. 2, No. 2, October 25, 1913.)

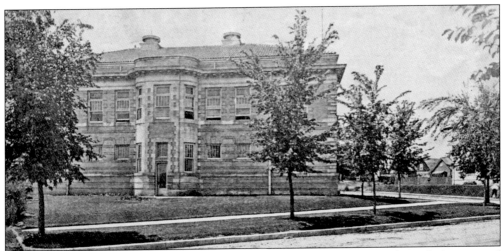

Shown here is one of the Capitol Hill fire stations, Fire House No. 15, at Eleventh Avenue and Clayton Street. After the fire department moved out, the landmark building was restored and converted to a single-family home, complete with an antique fire truck. (*Denver Municipal Facts*, Vol. 4, No. 38, September 21, 1912.)

Written in pencil on the back of this photograph, in old-fashioned handwriting, is the description "at Mrs. Weiss' home at 11th and Monroe." Census records show that a Katherine Weiss lived at 1021 Monroe Street in 1910, about the time this snapshot would have been taken. Weiss had two sons, Carl and Robert, probably the boys in this photograph. The home still stands, with this area of the Congress Park neighborhood being a mostly intact residential area of middle-class, early-20th-century homes. (Author's collection.)

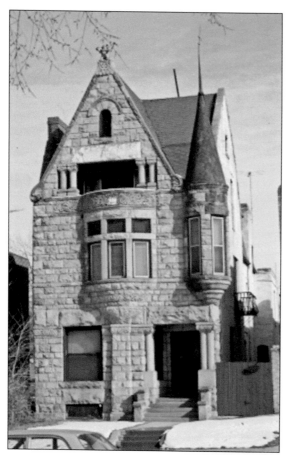

The house at 1532 Emerson Street has associations with several prominent Denver architects. Built in 1889, it was the work of architect William Lang. The house famously featured a gargoyle standing atop the roofline. Often referred to as the Zang Townhouse, it was the home of Adolph Zang before he moved to his mansion at Seventh Avenue and Clarkson Street. The two-year-old boy in the photograph below is Alan Golin Gass, who would grow up to be a significant architect and urban designer practicing in Denver, New York City, and Aspen. His grandparents, Joseph and Mollie, bought the townhouse in 1920, where they lived until Joseph's death in 1943. Before them, Camilla Edbrooke, the widow of architect Frank Edbrooke, had been a previous owner of the house. Joseph Gass also built the apartment building next door, at 1528 Emerson Street, designed around 1926 by architect Walter Simon. The Gass family was active in Congregation Emanuel and, before returning to Denver, owned a store in Platteville. (Both, Alan Golin Gass.)

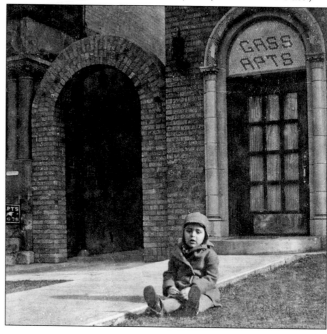

Photographer Harry Rhoads shot some of early- and mid-20th-century Denver's most memorable photographs. Rhoads worked for the *Rocky Mountain News* for 60 years, gaining a reputation for using every means possible to get his shot—but was also much beloved as a fun, good-natured jokester who loved taking "cheesecake" photographs of scantily-clad women. Rhoads was also a devoted family man. Numerous photographs document family celebrations, vacations, and even their everyday life. Married twice, Rhoads and his second wife, Sade, (his first wife, Julia, had died of tuberculosis) had two daughters, Mary Elizabeth and Harriet. Rhoads and his family lived at 642 Logan Street. (Denver Public Library Western History Collection.)

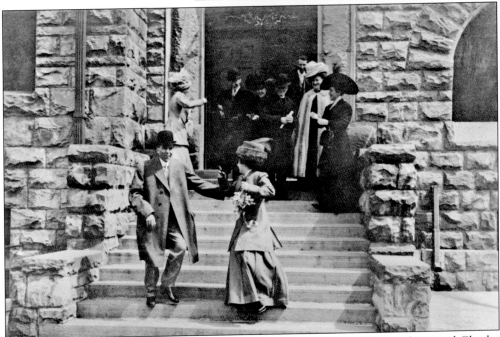

Harry Rhoads was also very close to his sister, Hazel. On April 4, 1910, Hazel married Charles Gates, head of the Gates Rubber Company. They would be married for 51 years. Harry Rhoads snapped this photograph of his sister and brother-in-law as they left the Plymouth Congregational Church at Fourteenth Avenue and Lafayette Street. (Photograph by Harry Rhoads; Denver Public Library Western History Collection.)

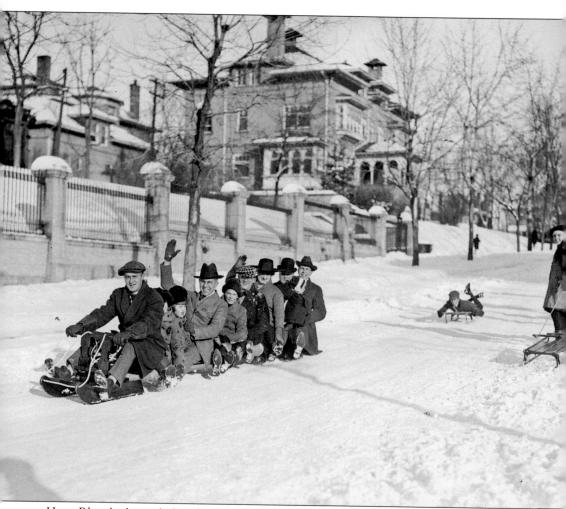

Harry Rhoads also took this photograph of children and their fathers, including some members of the Rhoads and Gates families, sledding down Eighth Avenue on a snowy day. In the background can be seen Hal Sayre's mansion, known as Alhambra, which still stands at Eighth Avenue and Logan Street directly east of the now-demolished Moffat Mansion. (Photograph by Harry Rhoads; Denver Public Library Western History Collection.)

Simon Guggenheim was another notable Capitol Hill resident who lived in a large mansion on Sherman Street and Colfax Avenue. Simon's father, Meyer Guggenheim, had made a fortune in mining and smelting. Simon and his brothers continued their father's empire, later expanding into the coal and oil business. Jerome Smiley, in his 1901 *History of Denver*, described Guggenheim as possessing "a winning personality and a generous nature." (*History of Denver*, Jerome Smiley, 1901.)

Judge Benjamin Barr Lindsey is known for his efforts with Denver's juvenile courts. During his years as a young attorney, Lindsey had rented a basement apartment at 1343 Ogden Street. Lindsey devoted himself to helping orphans and neglected youngsters who ran the streets, causing trouble because they didn't know any better. Lindsey advocated teaching children right from wrong, not just punishing them. Denver's children came to admire Lindsey, but others in the city did not. Lindsey's landmark book, *The Beast*, exposed the Denver political machine's rampant corruption. Wealthy businessmen ensured Lindsey's defeat in his run for governor and even went so far as to disbar him, after which he moved to California in 1931. Shown here is Lindsey with his adopted daughter, Benetta. (Denver Public Library Western History Collection.)

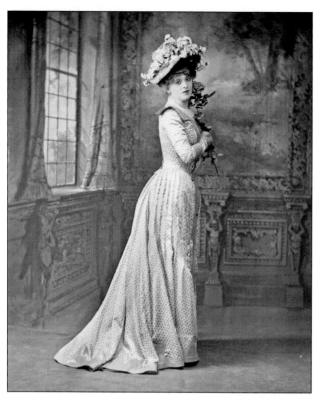

Other nationally known figures with ties to Capitol Hill include several silent movie stars. Jobyna Howland, shown here, grew up on Capitol Hill, her parents living in a now-demolished home at Seventeenth Avenue and Humboldt Street. Howland, who stood 6 feet tall, gained fame as the first Gibson Girl. She later went on to act on stage and in silent films. (Photograph by Rose and Hopkins; Denver Public Library Western History Collection.)

One of silent films' greatest comedians also grew up in Denver, attending Capitol Hill's Wyman School at Sixteenth Avenue and Williams Street. Harold Lloyd, who rose to prominence starring in such comedy features as *Safety Last*, was born in Nebraska. His family moved around frequently but eventually settled in Denver. Lloyd's autobiography includes boyhood memories of rolling down the grassy hills around the state capitol and tagging along to watch the older boys in the "Tenth Avenue Gang" fight the "Colfax Gang." Lloyd also had a paper route near his home in the City Park area. His mother, Elizabeth, shown with him in this photograph, continued to live in Denver after her son moved to Hollywood. (*An American Comedy*, Harold Lloyd and W. W. Stout, 1928.)

Future First Lady Mamie Doud Eisenhower grew up on Capitol Hill in a Foursquare house at 750 Lafayette Street, attending Miss Wolcott's School. In 1916, she married Dwight D. Eisenhower in the family home. During Eisenhower's presidency, the couple would frequently vacation in Denver, often staying with the Douds on Lafayette Street. The home has since passed through several owners, but many Eisenhower-era touches remain in the home, such as the velvet rope installed at the top of the stairs to keep the press out of the private family space. Pictured above is President Eisenhower in front of 750 Lafayette, while an earlier photograph below shows Mamie as a girl, standing with her sisters on the porch as their parents, John and Elivera Doud, drive off. (Both, Denver Public Library Western History Collection.)

In an interesting shot of everyday life on Capitol Hill, workers pave at Eleventh Avenue and Elizabeth Street. The large machine is a cement mixer. (*Denver Municipal Facts*, Vol. 3, No. 22, May 27, 1911.)

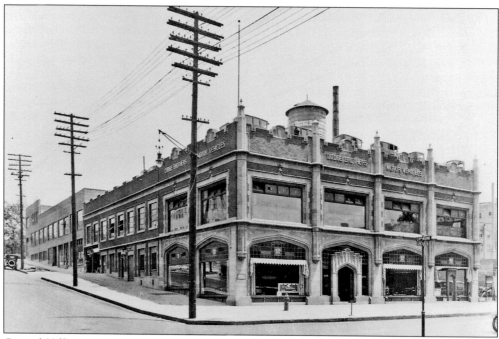

Capitol Hill's commercial structures were not limited to Colfax Avenue. Most of the numbered avenues north of Eleventh have at least a small commercial area mixed in with residential structures. This building on the edge of Capitol Hill, at Thirteenth Avenue and Lincoln Street, started out as a Dodge dealership, one of a number of automobile showrooms located in Capitol Hill. By the 1960s, the Denver Automotive and Diesel College occupied the building. Finally, in the 1980s, the Colorado Ballet moved in, transforming the old dealership into offices and a second-floor studio. (Tom Noel Collection.)

The car shown in each of these photographs belonged to Seeing Denver, a touring company. Capitol Hill certainly offered much to see, for visitors and residents alike. Along with stops at popular Capitol Hill spots like City Park, Seeing Denver tours visited many places around the Capitol Hill neighborhood. In the above photograph, a Seeing Denver tour makes its way down Ninth Avenue. In the image below, the tour car drives up the hill on Sixteenth Avenue from Broadway, past the YMCA building and the Central Christian Church. A much photographed, much visited, and much loved area, Capitol Hill has, throughout its history, offered much to see and experience. (Both, *Denver Municipal Facts*, Vol. 3, No. 44, October 28, 1911.)

Bibliography

Brettell, Richard. *Historic Denver: The Architects and Architecture.* Denver, CO: Historic Denver, 1973.

Colorado General Assembly. *Granite & Gold: The Colorado State Capitol, the Pride of Our People.* Denver, CO: State of Colorado, 1992.

Davis, Sally, and Betty Baldwin. *Denver Dwellings & Descendants.* Denver, CO: Sage Books, 1963.

Engle, Morey, and Bernard Kelly. *Denver's Man with a Camera: The Photographs of Harry Rhoads.* Evergreen, CO: Cordillera Press, 1989.

Everett, Derek R. *The Colorado State Capitol: History, Politics, Preservation.* Boulder, CO: University Press of Colorado, 2005.

Goodstein, Phil. *The Ghosts of Denver: Capitol Hill.* 2nd ed. Denver, CO: New Social Publications, 1998.

Haber, Francine, Kenneth R. Fuller, and David N. Wetzel. *Robert S. Roeschlaub: Architect of the Emerging West, 1843–1923.* Denver, CO: Colorado Historical Society, 1988.

Jones, William, and Kenton Forrest. *Denver: A Pictorial History.* 2nd ed. Boulder, CO: Pruett Publishing, 1985.

———, Gene C. McKeever, F. Hol Wagner Jr., and Kenton Forrest. *Mile High Trolleys: A Nostalgic Look at Denver in the Era of the Streetcars.* 2nd ed. Denver, CO: Intermountain Chapter, National Railway Historical Society, Inc., 1975.

Lloyd, Harold, and W. W. Stout. *An American Comedy.* New York: Longmans, Green, and Company, 1928.

Noel, Thomas J. *Denver Landmarks & Historic Districts: A Pictorial Guide.* Niwot, CO: University Press of Colorado, 1996.

——— and Barbara S. Norgren. *Denver, The City Beautiful and its Architects, 1893-1941.* Denver, CO: Historic Denver, Inc., 1987.

——— and Amy B. Zimmer. *Showtime: Denver's Performing Arts, Convention Centers, and Theatre District.* Denver, CO: City and County of Denver, 2008.

Simmons, Laurie, and Thomas H. Simmons. *East Colfax Avenue.* Denver, CO: Historic Denver, 2007.

Smiley, Jerome. *History of Denver.* Denver, CO: Times-Sun Publishing Company, 1901.

White, James H. *The First Hundred Years of Central Presbyterian Church, Denver 1860–1960.* Denver, CO: Great Western Stockman Publishing Company, 1960.

Index

DISCOVER THOUSANDS OF LOCAL HISTORY BOOKS
FEATURING MILLIONS OF VINTAGE IMAGES

Arcadia Publishing, the leading local history publisher in the United States, is committed to making history accessible and meaningful through publishing books that celebrate and preserve the heritage of America's people and places.

Find more books like this at
www.arcadiapublishing.com

Search for your hometown history, your old stomping grounds, and even your favorite sports team.

Consistent with our mission to preserve history on a local level, this book was printed in South Carolina on American-made paper and manufactured entirely in the United States. Products carrying the accredited Forest Stewardship Council (FSC) label are printed on 100 percent FSC-certified paper.